50 GEM

Guernsey

SOO WELLFAIR

AMBERLEY

Dedicated to Mum and Dad, who would have loved this!

First published 2022

Amberley Publishing
The Hill, Stroud
Gloucestershire, GL5 4EP

www.amberley-books.com

British Library Cataloguing in Publication Data.
A catalogue record for this book is available from the British Library.

ISBN 978 1 3981 0356 6 (paperback)
ISBN 978 1 3981 0357 3 (ebook)

Typesetting by SJmagic DESIGN SERVICES, India.
Printed in Great Britain.

Contents

Introduction

Discover Guernsey, a beautiful Channel Island with a fascinating history and breathtaking scenery. With an area of just 24 square miles, you'll be astonished at just how much there is to see and do. With a varied landscape that ranges from beautiful beaches, stunning cliffs and lush countryside, to the quirky, cobbled streets of the harbour-town St Peter Port, you will find yourself immersed in the delights of this quaint and charming island.

Lose yourself as you explore some of Guernsey's hidden treasures. Seek out the tiny chapel decorated in broken pieces of pottery, and the clifftop woodland that comes alive every year when it is swathed in a blanket of bluebells. Explore Guernsey's historic sites from throughout the island's history, from Neolithic times, through to the medieval and Tudor periods, and even to the more contemporary structures built during the Occupation of Guernsey during the Second World War.

Guernsey is an island that is small in size but immense in history and beauty. The Bailiwick of Guernsey is made up of a number of islands including Herm, Sark and Alderney, which can be easily reached from Guernsey and can make a very interesting extension to your trip. A section on 'Island Hopping' is included later in this book.

St Peter Port

1. Castle Cornet

Castle Emplacement, St Peter Port, GY1 1AU

If you arrive in Guernsey by sea, you will be welcomed by the sight of Castle Cornet. When Guernsey became loyal to the English crown in 1204, the island became vulnerable to French invasion and Castle Cornet was built soon after. Initially a tidal castle, Castle Cornet could only be reached by boat or at low tide. The castle has been much adapted over the centuries and has parts from the medieval period, sections which are from Tudor times, artillery from the times of the Napoleonic Wars, not to mention the fortifications added during the Occupation.

The castle used to have a keep, but this was destroyed when it was struck by lightening in 1672. The governor of the island at the time was living in the castle, and his living quarters were also destroyed, along with the chapel and great hall. The governor, Lord Hatton, and his children survived. However his wife, mother and several others died in this terrible incident. No governor has ever lived in the castle since.

During the English Civil War, Castle Cornet became a Royalist stronghold. The majority of islanders, however, had sided with the Parliamentarians and therefore Guernsey was at war with herself for nine years. Cannonballs were regularly fired from St Peter Port to the castle and vice versa and recently an intact cannonball was discovered embedded deep in one of the castle's walls. Castle Cornet was actually the very last Royalist stronghold to surrender during this war.

The castle is now open to the public between the end of March and November (check seasonal opening times). There are several museums within the castle, as well as some beautiful gardens, a cafe and a gift shop. There is a daily guided walk shortly after the castle opens, followed by the firing of the Noon Day Gun, which is a 'must-see' part of your castle visit. After the Noon Day Gun you can watch a short performance by Living History, who re-enact stories from Guernsey's history. It is one of four sites in Guernsey where the Discovery Pass can be used (see http://www.museums.gov.gg/DiscoveryPass for details).

www.museums.gov.gg/Castle-Cornet

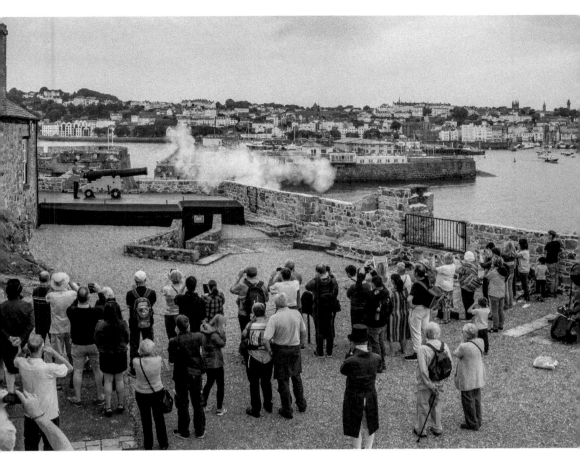

The firing of the Noon Day Gun, Castle Cornet. (Guernsey Museums & Galleries)

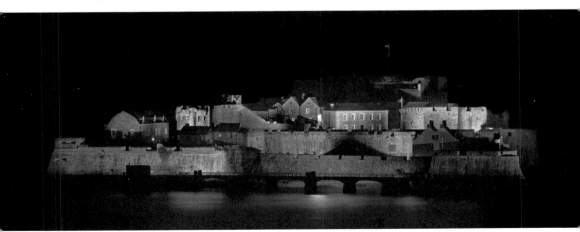

Castle Cornet at night. (J. M. Dean)

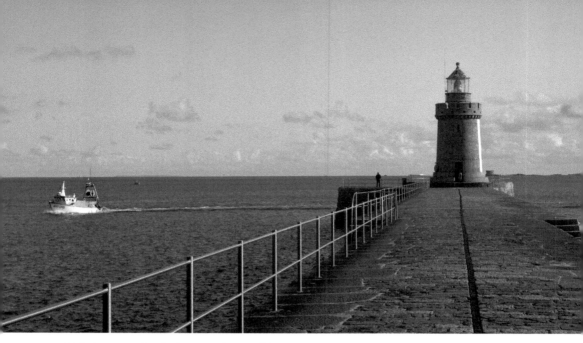

Lighthouse at Castle Cornet. (Soo Wellfair)

2. Candie Gardens and Museum

Candie Road, St Peter Port, GY1 1UG

Candie Gardens was established in 1894 as the gardens to Candie House (now the Priaulx Library).

The gardens are split across two levels, with an upper and lower garden. The lower garden is very much Victorian in style and has a wide variety of flowers and plants. The beautiful greenhouse in the lower gardens is thought to date back to the eighteenth century and is believed to be the oldest of its kind in the British Isles. The glasshouse has, in the past, been used to display the various varieties of the Guernsey Nerine (lily), during the annual Nerine Festival. The red *nerine sarniensis* is considered to be the most beautiful and has a wonderful chocolate scent!

The statue of Queen Victoria in the grounds was unveiled in 1900 to mark her Diamond Jubilee. Not far from here is the Victoria Tower, built shortly after Queen Victoria visited the island. It is open to the public, and the key can be obtained from the museum's front desk. Once you have the key you are able to take the ninety-nine steps to the top of the tower and enjoy the amazing views from the observation deck.

There is also a statue of the famous French writer Victor Hugo in the garden grounds. Hugo lived in Guernsey between 1855 and 1870. During this time, he completed *Les Miserables* and wrote a novel based in Guernsey called *Les Travailleurs de la Mer*, amongst others.

The Guernsey Museum at Candie is the place to find out all about Guernsey's rich history. With permanent exhibitions of Guernsey's historical timeline, folklore and

art, as well as temporary exhibitions which change throughout the year, the Guernsey Museum has something for everyone. It is one of four sites in Guernsey where the Discovery Pass can be used. The Discovery Room is a fantastic place for children to explore and play with toys from a bygone era. The museum also boasts a delightful tearoom, located in what was once a Victorian bandstand.

In the summer there are regular open-air concerts in the upper gardens (check website for details). Make sure to look out for a plaque on the outside of the museum which marks the day in 1963 when The Beatles played at Candie Gardens.

www.museums.gov.gg/gmag

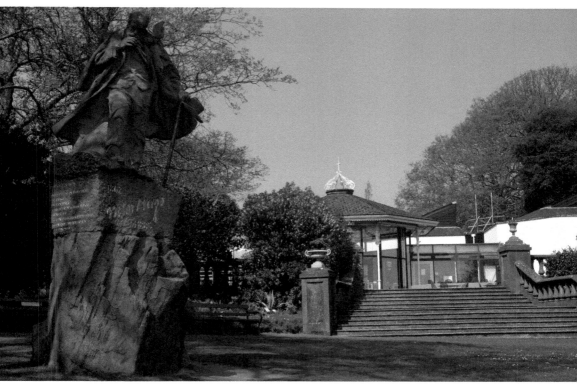

Above: Statue of Victor Hugo at Candie Gardens. (Soo Wellfair)

Right: The Guernsey Museum at Candie. (Soo Wellfair)

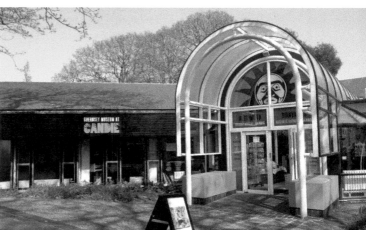

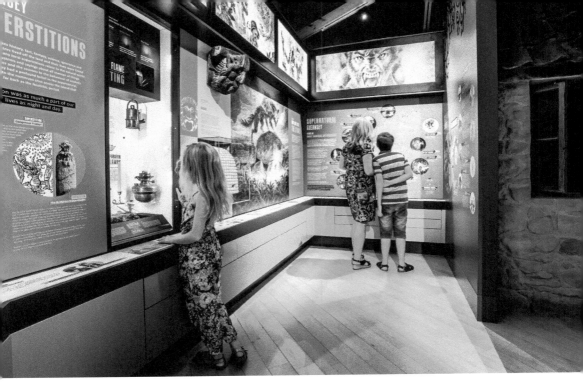

Folklore exhibition at Guernsey Museum at Candie. (Guernsey Museums & Galleries)

3. Victoria Tower

Arsenal Road, Guernsey, GY1 1WQ

In 1946, islanders were treated to a brief but exciting royal visit when Queen Victoria and Prince Albert visited Guernsey. Victoria Tower was built two years after this visit and the Queen returned a second time to view the completed tower. Standing at around 100 feet tall and constructed of mostly local pink granite from Cobo, the tower was built at a cost of £2,000. Buried in the foundations is a time capsule containing a selection of coins from both Guernsey and England.

The tower is situated next to what was once the town arsenal, used by the Royal Guernsey Militia but now being used by the local fire service.

The gardens surrounding the tower are also home to two rather large pieces of artillery. These guns are thought to be of German origin and date back to the First World War. They were hastily buried in 1940 to prevent occupying forces using them during the Second World War and remained underground until 1978, when they were recovered, restored and put in place where they are today.

Although the tower is locked, the key can be taken out on loan from the Guernsey Museum at Candie Gardens, and visitors are able to climb the ninety-nine steps to the viewing platform at the top of the tower to enjoy the amazing panoramic views.

www.museums.gov.gg/victoriatower

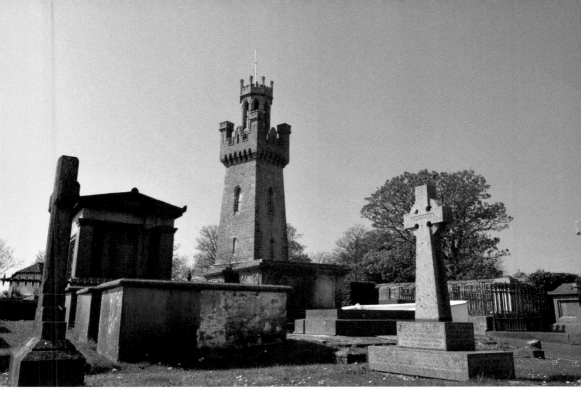

Above: Victoria Tower, taken from Candie Cemetery. (Soo Wellfair)

Right: Victoria Tower. (Soo Wellfair)

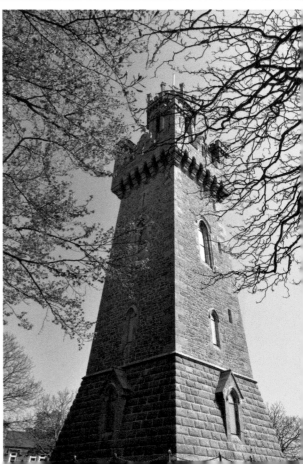

4. Clarence Battery

La Terre Point, St Peter Port

One of more than sixty batteries built in Guernsey in the late eighteenth century, Clarence Battery is a popular site for visitors due to the amazing views offered by its elevated position. It was built to form part of the outer defences of Fort George and was originally named the Terres Point Battery. It was later renamed the Clarence Battery in honour of the son of King George III and is known locally as the Cow's Horn. There is a delightful footpath which starts at the bottom of the Val des Terres (the long, winding road which links St Peter Port and St Martin) which leads you around the outside of Fort George and to the entrance to Clarence Battery. It is also possible to access Clarence Battery from the other direction, coming from the south cliffs paths towards St Peter Port.

The area is well preserved and much of the site is still intact, as well as showing some evidence of the modifications made when the Battery was used by occupying forces during the Second World War. It is a very pretty area, and is a lovely spot to stop off and relax when walking along the coastal paths of the south coast.

Gun placement at Clarence Battery with views over Castle Cornet. (Soo Wellfair)

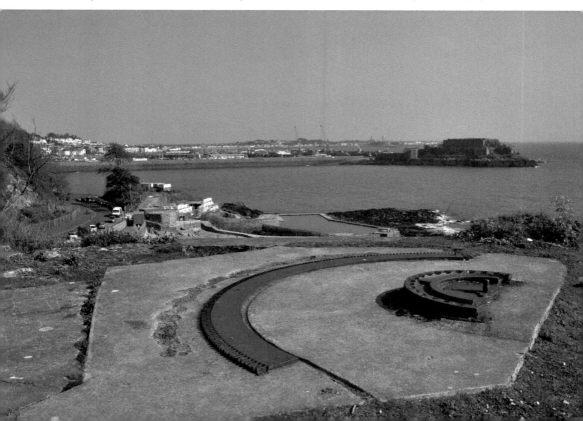

Clarence Battery. (Soo Wellfair)

5. Hauteville House (Victor Hugo's House)

Hauteville, St Peter Port, GY1 1AU

French author Victor Hugo lived in Guernsey from 1855 to 1870. He had been exiled from France after labelling Napoleon III a traitor after he abolished the democratic system. During this time he worked on many of his novels and plays. He completed *Les Miserables* and wrote a Guernsey-based novel named *Les Travailleurs De La Mer* or *The Toilers of the Sea*, amongst others. It is considered to be Hugo's most productive writing period. As well as his works of fiction, Hugo also wrote about the island and his observations whilst living here, and was also an accomplished artist, sketching many scenes from around his adopted home. During most of this time, Hugo lived and worked in Hauteville House in St Peter Port. He spent fourteen years there and lavishly decorated the house in his own eccentric style. The house is built on five floors and is considered to be a work of art from top to bottom. The views from the top floor are spectacular.

The house was donated to the City of Paris in 1927 and is open to the public as a museum. Guided tours are available in both English and French and must be booked

in advance (check seasonal opening times). You can also visit the beautiful gardens and the 'Oak of the United States of Europe', which started out as an acorn planted by Hugo and his grandchildren.

In 2018 a wealthy businessman donated £2.6 million, which enabled an extensive restoration of the property to take place.

https://www.maisonsvictorhugo.paris.fr/en

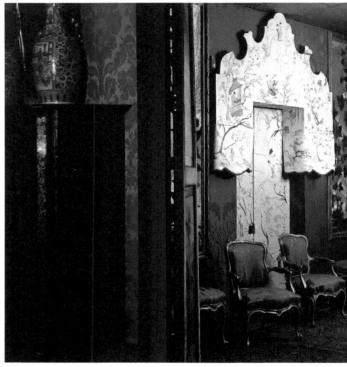

Above left: Hauteville House – the former home of Victor Hugo. (Soo Wellfair)

Above right: Inside Hauteville House. (Paris Musées Maisons de Victor Hugo Paris/ Guernesey)

Left: Victor Hugo's dining room, Hauteville House. (Paris Musées Maisons de Victor Hugo Paris/Guernesey)

6. La Vallette Bathing Pools

La Vallette, St Peter Port, GY1 1AX

If you love the idea of swimming in the sea with the security of a swimming pool, then you really must visit the bathing pools at La Vallette. Situated near Havelet Bay in St Peter Port, these open-air pools have been popular since they were built during the Victorian times. The horseshoe pool was the first to be built in 1859, followed by the gents' and ladies' pools, and eventually the children's pool was added in 1896. With amazing views of the town, Castle Cornet and some of Guernsey's neighbouring islands, it is a very special spot to swim or simply relax. The bathing pools are refreshed with a top-up of seawater twice a day, at high tide. Guernsey actually has the third highest tidal range in the world.

Victor Hugo was known to have been a regular visitor to the pools when he lived in Guernsey. During the Occupation the pools were used to 'de-louse' a shipment of clothing and furniture which was being stored amongst livestock in Alderney. There are changing rooms and showers on site, as well as a café serving refreshments (check seasonal opening hours).

The bathing pools form part of a beautiful, well-maintained Victorian promenade and gardens which is often used as the venue for local art exhibitions.

The bathing pools at La Vallette. (Soo Wellfair)

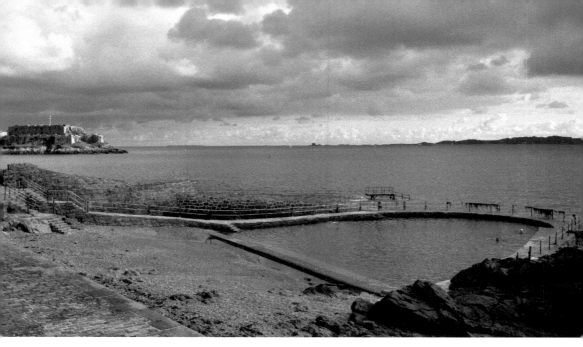

The bathing pools at La Vallette. (Soo Wellfair)

7. The Victorian Shop and Parlour

No. 26 Cornet Street, St Peter Port, GY1 1LF

The Victorian Shop and Parlour really is a hidden gem of Guernsey. No. 26 Cornet Street is thought to be one of the oldest standing buildings in St Peter Port with the original structure dating back to medieval times. This is quite a rarity as although we know there was a medieval town, very little remains from those early days. Although much of what we can see today of the building dates back to the eighteenth century, with some nineteenth-century modifications, it is still an important historical site.

During Victorian times No. 26 Cornet Street was a confectionery shop with living quarters for the shopkeeper's family. Today, this set-up has been lovingly recreated for the modern-day visitor. Open to the public, No. 26 Cornet Street can be considered part-shop, part-museum and offers a fascinating snapshot of Victorian life. In the shop you can treat yourself to some of your favourite childhood sweets, sold by weight (metric and imperial). You will also find a delightful selection of gifts and crafts to purchase, many handmade locally and in the UK. Sewing enthusiasts will appreciate the beautiful fabrics and items from the vintage haberdashery. The items on sale are not available anywhere else on the island and wherever possible are ethically sourced. In the beautifully restored parlour you will find an eclectic display of Victoriana.

This quirky National Trust site is free to enter and offers a truly unique experience for visitors. Check the website and Facebook page for the latest news and events.

https://nationaltrust.gg/places/victorian-shop-parlour

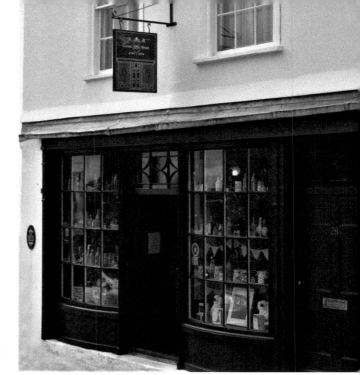

Right: No. 26 Cornet Street, St Peter Port. (Soo Wellfair)

Below: The Victorian Shop and Parlour. (Soo Wellfair)

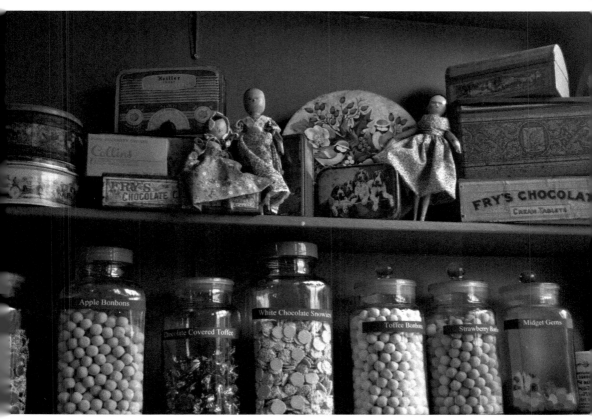

The Victorian Shop and Parlour. (Soo Wellfair)

8. The Guernsey Tapestry and the St James Concert Hall

College Street, St Peter Port, GY1 2NZ

Based at the beautiful St James Concert Hall building, the Guernsey Tapestry is an ingenious way to experience 1,000 years of local history. The tapestry was completed as an island-wide community project, with the first stitch added in 1996 and the last in 1998. It was to become an important part of Guernsey's Millennium celebrations in 2000.

Guernsey is divided into ten parishes: St Peter Port, St Martin, St Andrew, Torteval, St Pierre du Bois, Vale, St Saviour, Forest, Castel and St Sampson. Islanders from each parish worked together to produce a panel, each one covering a century of Guernsey's history. Each panel measures 4 feet by 3 feet and the tapestries were worked on for around twenty-five hours a week.

The Guernsey Tapestry is open to the public (please check seasonal opening times) and there is a gift shop on-site. St James also has a restaurant in the main building.

The St James building itself has a very interesting history. It was opened in 1818 as an English-speaking chapel, aimed at the various British army regiments garrisoned

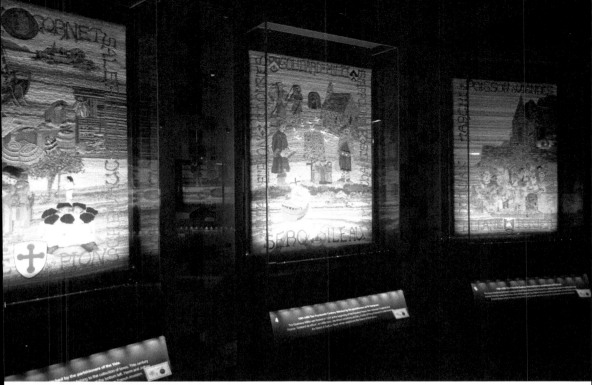

Above and right: The Guernsey
Tapestry. (Soo Wellfair)

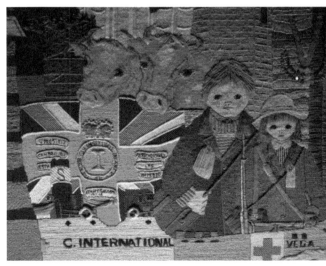

in Guernsey as the town church still held services in French at this time. After
spending many years as the chapel for Elizabeth College (just across the road) it fell
into a state of disrepair before being renovated and reopened as a music venue in
1985. It is now used as an extremely successful live entertainment venue as well as
being an increasingly popular location for weddings.

www.guernseytapestry.org.gg
www.stjames.gg

9. The Seafront and Harbour

Seafront and Piers, St Peter Port

St Peter Port's seafront is quite often the first thing visitors will see in Guernsey if they arrive by sea, where they will be greeted with a colourful panorama of Guernsey's multi-levelled seafront architecture. The harbour is home to a bustling ferry port, used for passengers and freight, and a number of smaller piers and marinas which stretch from the ferry terminus to the castle emplacement. Several of the piers house wonderful restaurants which boast spectacular views over the harbour and towards the neighbouring islands. St Peter Port Harbour also connects Guernsey to the rest of the Bailiwick with regular boats to Herm, Sark and Alderney. It is also possible to book rib rides, wildlife tours and fishing trips during the peak season.

Seafront Sundays are a quintessential part of the Guernsey summer. Although the dates can vary year by year, the format is always the same. On around eight Sundays between May and August, the seafront in St Peter Port is closed off to traffic for the day. It is an amazing opportunity to enjoy a stroll along the seafront and experience Guernsey's bustling town in a completely different way. Each Seafront Sunday has a theme and you will find a colourful array of stalls and vendors stretched along the main road as well the various piers. Many of the stallholders do not sell in stores, so it is a rare chance to purchase some of the items on offer. Stalls are an eclectic mix of home-made crafts, baked goods, antiques, books, clothing, jewellery, decorative items, artwork, photographic gifts and much more. You'll be able to taste some amazing local produce

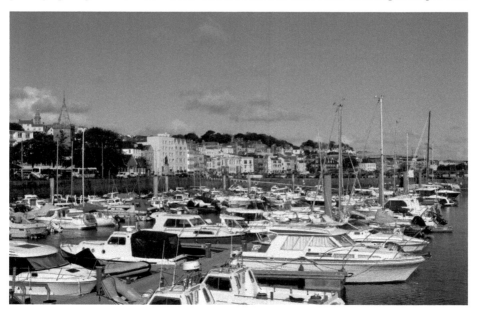

St Peter Port harbour and seafront. (Soo Wellfair)

Seafront Sunday, St Peter Port. (Soo Wellfair)

from the vast array of catering vendors and be entertained by some of the island's most talented musicians. The atmosphere is electric and the al fresco hustle and bustle of a Seafront Sunday is an occasion to be experienced by every visitor to the island.

www.visitguernsey.com

10. Tower Hill

Tower Hill, St Peter Port, GY1 1DF

Tower Hill is the site of the Guernsey witch trials and is an atmospheric area well worth a visit if you are in town. You can access the Tower Hill steps from two different places. You can either walk up them from Fountain Street, or follow the hill up Cornet Street to Tower Hill and walk down them. If you come up Cornet Street you will pass a raised area known as the Mignot Plateau, the site of the former Tour de Beauregard. This was where the condemned were tortured and imprisoned before execution.

Between the mid-sixteenth and mid-seventeenth centuries it's believed that around 100 people in Guernsey were put on trial for witchcraft. Guernsey was a very superstitious island in those times as well as being caught up in a great deal of religious unrest and change. The most famous case is that of Catherine Cauches and her two

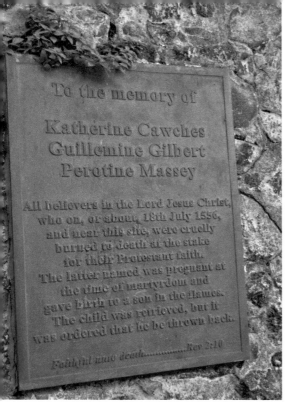

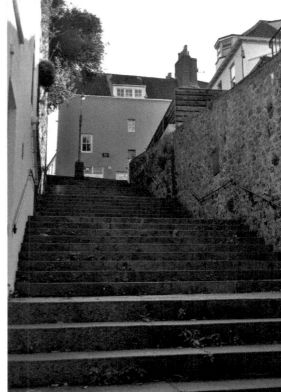

Above left: The Guernsey Martyrs Memorial plaque. (Soo Wellfair)

Above right: Tower Hill steps, St Peter Port. (Soo Wellfair)

daughters Guillemine Gilbert and Perotine Massey. Found guilty of heresy in 1556 because of their Protestant beliefs, the three women were burnt at the stake on this site. As you will see for yourselves if you read the plaque halfway down the steps, there is a rather unpleasant twist to this tale. Perotine Massey was heavily pregnant at the time of execution and gave birth to a child, when premature labour was induced the shock of the fire. The child was retrieved and thrown back into the flames by order of the Bailiff. They are in the Foxe's Book of Martyrs, known as the Guernsey Martyrs.

If you are interested in the folklore of Guernsey there is a fantastic exhibition within the Guernsey Museum at Candie.

11. Bluebell Woods

Access from south cliff paths

Every spring, Guernsey's landscape becomes a delightful shade of blue and purple as the bluebells come into bloom. The best place to see the bluebells at their most

beautiful is by taking a walk from St Peter Port around the coastal path towards Fermain Bay. On the way you will pass through the Bluebell Woods, a beautiful, tranquil area of woodland covered in a blanket of bluebells, usually from mid-April until the end of May or beyond.

The native bluebell is currently under threat from an invasive Spanish variety. It is thought they were introduced by islanders purchasing bulbs from garden centres and they are now widespread around the island and beginning to take over areas once dominated by the native variety. Although both varieties are colourful and attractive, it is important to preserve the native bluebell, so measures are being undertaken to curb the spread of the Spanish type.

If you visit the Bluebell Woods, do carry on along the coastal path to visit the picturesque Fermain Bay, which has a historic loophole tower and a lovely little cafe and kiosk overlooking the bay.

https://fermainbeachcafe.gg/

The Bluebell Woods.
(Soo Wellfair)

12. German Naval Signals Headquarters

St Jacques, St Peter Port, GY1 SN

Situated in the area of St Jacques in St Peter Port, the German Naval Signals HQ is just a short walk from the Guernsey Museum at Candie. It is one of four sites in Guernsey where the Discovery Pass can be used.

The headquarters were used as a command centre of the German Naval Commander of the Channel Islands during the Occupation. They were initially based in the hotel next door but eventually a permanent bunker was specially built within the hotel grounds. All-important radio signals being transmitted to and from Guernsey were handled here. They were even using Enigma coding machines, which were famously decoded by the staff at Bletchley Park in the UK.

Now open to the public as a museum, the bunker has been restored faithfully, with many of the original fittings still in place. It is also possible to arrange private viewings by contacting Festung Guernsey, who take care of many of the fortifications around the island.

The exhibits and rooms have been recreated with first-hand advice from former German personnel, including the Naval Signals Officer.

http://www.museums.gov.gg/GNSHQ
http://festungguernsey.org.gg/

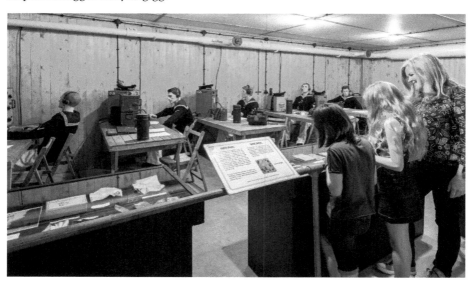

German Naval Signals HQ. (Guernsey Museums & Galleries)

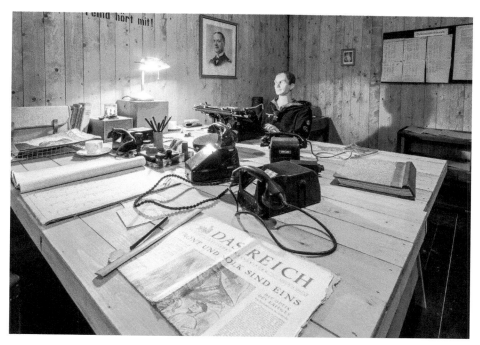

German Naval Signals HQ. (Guernsey Museums & Galleries)

13. The Liberation Monument and Liberation Day

St Julian's Pier, St Peter Port, GY1 2LL

Every year Guernsey celebrates Liberation Day. Guernsey was occupied for almost five years during the Second World War and on 9 May 1945 the island was liberated. It is a unique and special public holiday and is a wonderful mix of celebration and remembrance. Liberation Day is a popular event for visitors as well as locals, with many people travelling to Guernsey to take part in the festivities. Around this time each year, you will find homes all across the island swathed in Guernsey flags and bunting, as well as the colours of the Union Flag. Most people get into the spirit of the occasion, and it is delightful to see the colourful decorations which transform the island every May. There are usually various events leading up to the day itself, such as themed guided walks, open days of various fortifications, museum exhibits, themed dinners and so forth. On the day itself there is always a full schedule of events, with St Peter Port being the focus of many of the day's key activities, with individual parishes usually

offering a local, community-based programme as well. There is a church parade and memorial service in the Town Church, a cavalcade of military vehicles which makes its way around the island, live music and dancing, children's activities and fireworks.

The Liberation Monument in St Peter Port was unveiled by HRH The Prince of Wales on Liberation Day in 1995, marking fifty years of freedom. The monument is made of fifty layers of Guernsey granite, each representing a year of liberation, and the cut angle at the top signifies the trauma caused by the Occupation years. It was designed by local artist Eric Snell and is inspired by the many prehistoric megaliths that are dotted around the island. The ingenious thing about the monument is how it acts as a timeline sundial. On 9 May each year, the monument casts a shadow on the seating area behind it, highlighting three inscriptions depicting important events of that day, at the exact time they occurred back in 1945. It is extremely accurate and quite unique! The location of the Liberation Monument is also significant. The area just behind the monument, known as White Rock, was tragically bombed just before the island was occupied, as enemy planes mistook innocent tomato trucks unloading at the harbour for military vehicles. The results were devastating. If you follow the wall which makes up the side of North Beach car park, you will find a plaque dedicated to those who lost their lives during these bombings. It is one of many dedications in this area to various groups affected during the conflict.

A new statue was unveiled on Liberation Day in 2021. The sculpture is modelled on a real family from the present day dressed in clothing from 1945. Its purpose is to serve as a reminder of the freedom islanders enjoy thanks to the sacrifices made by those who were present during the Occupation. The arms of the mother and daughter are outstretched and people are encouraged to hold hands with them, creating a link between the past, present and future.

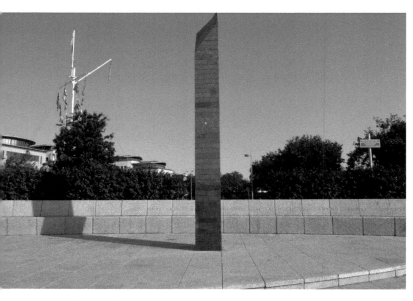
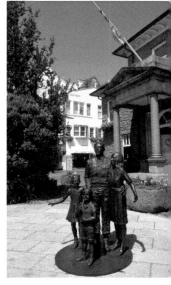

Above left: Liberation Monument. (Soo Wellfair)

Above right: Liberation Day Sculpture. (Soo Wellfair)

St Martin

14. Sausmarez Manor

La Route De Sausmarez, St Martin, GY4 6SG

Sausmarez Manor (not to be confused with Saumarez Park) is a stunning manor house located in the parish of St Martin. It is possible that parts of the house may date back to as early as the twelth century.

During the Occupation (1940–1945) many large homes in Guernsey were taken over by the occupying forces. Sausmarez Manor would have been quite an attractive requisition, although it was never taken. The reason being the occupant at the time, Sir Havilland de Sausmarez, had refused to install electric lighting in the property!

The house and grounds are open to the public. Tours of the manor house can be booked in advance from April to October (see website for details) and the ghost tours are especially popular. The grounds are open daily throughout the year and are free to explore.

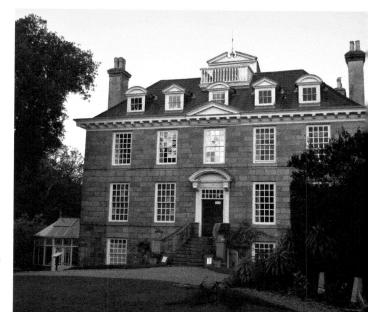

Sausmarez Manor. (Soo Wellfair)

There is much to see and do on site for the whole family, including the subtropical gardens, sculpture trail, train rides, pitch and putt course, coppersmiths, gift shop and cafe (check opening times and admission fees).

During the warmer months a busy farmer's market is held in the grounds every Saturday morning. It's a wonderful way to purchase some delicious local produce, whilst admiring the picturesque surroundings of the gardens. During the winter, the market moves to the local parish hall (usually from November to April).

https://www.sausmarezmanor.co.uk/

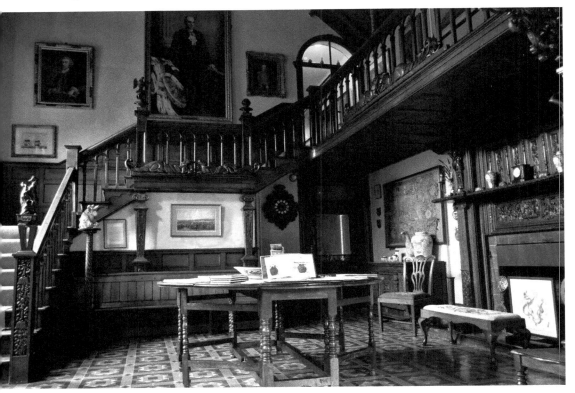

Above: Inside Sausmarez Manor. (Soo Wellfair)

Left: Sculpture in the grounds of Sausmarez Manor. (Soo Wellfair)

15. Jerbourg Point

La Route de Jerbourg, St Martin, GY4 6BG

They say that on a clear day you can see forever, and that is certainly true if you are standing at Jerbourg Point. Situated at the south-easternmost point of the islands, you may be lucky enough to catch a glimpse of Jersey or even the coast of France on a nice day.

Jerbourg is one of the easiest parts to join the southern cliff paths, with a main road leading all the way to the point, suitable for cars, bicycles and buses. If you are on foot you have even more options. You may wish to follow the main road, take a map and meander your way through the quiet green lanes or approach Jerbourg from the cliff paths.

However you reach your destination, you will be rewarded with stunning cliff-top views.

On your approach to Jerbourg you may have spotted a tall column. This is the Doyle Monument. The original was built in honour or Sir John Doyle, former Lt Governor of Guernsey, in 1820. Sadly, the monument was destroyed in 1944 when it inconveniently stood in the path of a rather large gun placement, put in place by the occupying forces. A much smaller version, which we see today, was erected after the war and completed in 1953.

View from Jerbourg Point. (Soo Wellfair)

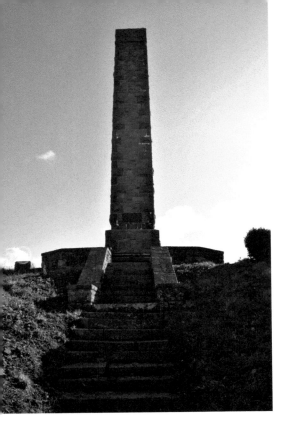

The Doyle Monument, Jerbourg.
(Soo Wellfair)

The Jerbourg kiosk is open for refreshments, and there are plenty of benches to enjoy an ice cream in the sunshine. You may also like to visit Hotel Jerbourg with its famous Cliff Top Coffee Shop, which serves a seemingly never-ending choice of delicious cakes, served to your table or as you relax in a comfortable armchair.

16. Moulin Huet

Moulin Huet, St Martin, GY4 6EJ

Moulin Huet is a beautiful, secluded bay. So beautiful in fact that it inspired the work of a famous artist. There was once a watermill on this site and Moulin Huet literally translates to Mill Huet, named after Mr Huet who owned it. French impressionist Renoir spent just over a month in Guernsey in 1883 and painted fifteen scenes around the Moulin Huet area. One of these paintings is titled *Cradle Rock*, named after a famous rock formation with an interesting story attached to it. Cradle Rock is known as 'le bate des tres garces' (the boat of the three maidens) and legend has it three young girls who fell asleep whilst sunbathing on the beach at low tide were taken by surprise when the tide suddenly rose, and as none of them could swim, they all drowned and were transformed into the large rock.

As you head down towards the bay from the nearby car park you will pass the Moulin Huet tearooms, which are a lovely place to enjoy some refreshments whilst admiring the views.

Moulin Huet is a pretty, secluded spot; it's popular with swimmers and makes a lovely area for a picnic. It also the perfect place to join the southern cliff paths and enjoy a cliff walk. You can either head towards Jerbourg and town or continue in the other direction and follow the path to Saint's Bay and beyond.

https://www.visitguernsey.com/eat-drink/eating-out-guide/moulin-huet-tea-rooms/

Right and below:
Moulin Huet.
(Soo Wellfair)

Renoir art installation, Moulin Huet. (Soo Wellfair)

17. La Gran'mère du Chimquière

The Rectory, off La Grande Rue, St Martin, GY4 6RR

You will find La Grand'mère stone menhir standing outside the gates of St Martin's Parish Church. The 'Grandmother of the Cemetery' is a very old lady indeed. This stone carving is thought to have originally been created around 4,000 years ago and re-carved around 2,000 years ago. The most recent carvings gave her clothes, similar to the type of garments Romans wore. This is why she also has the lesser-known nickname of the 'Grandmother of Julius Caesar'.

Nobody knows exactly where she came from or why she was created, although from the twentieth century onwards she has been seen as an earth goddess and a fertility symbol. It is traditional for brides getting married at the church to adorn the statue with flower garlands and coins for good luck.

It is thought that La Gran'mère was previously located within the grounds of the churchyard and was moved outside the gates by a clergyman who disapproved of her pagan roots. This could also explain how she came to be broken in half. There is a similar statue at Castel church.

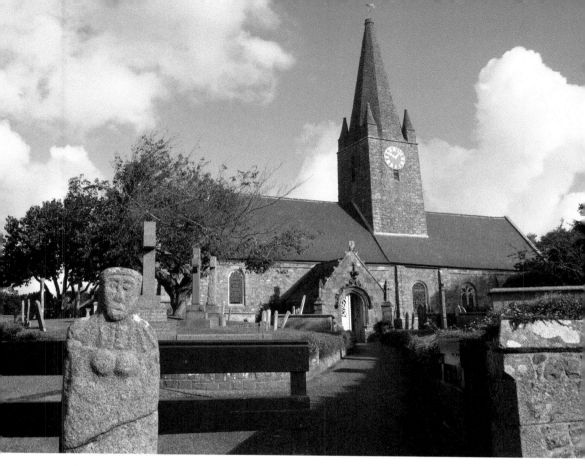

Above: La Gran'mère du Chimquière outside
St Martin's Church. (Soo Wellfair)

Right: La Gran'mère du Chimquière.
(Soo Wellfair)

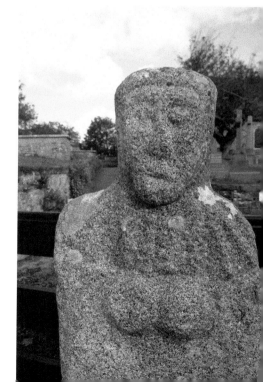

18. The Little Chapel

Les Vauxbelets, St Andrew, Gy6 8XY

Nestled within the beautiful valley area known as Les Vauxbelets, in the parish of St Andrew, lies the Little Chapel. Standing at just 16 × 9 feet, the Little Chapel may be small in size but it is mighty in visual impact. Based on the Rosary Basilica of Lourdes, every inch of the Little Chapel is adorned with a colourful array of broken china, seashells and pebbles and is an absolute feast for the eyes. This form of mosaic work is known as picassiette, which is French for 'plate stealer', and one of the most famous examples is La Maison Picassiette in Chartres, France.

The version of the Little Chapel which stands today is actually the third incarnation of this stunning landmark. It was originally built in 1914 by Brother Deodat, a member of a French monastic order known as the Brothers of the Christian Schools, who had settled in Guernsey in 1904. They were dedicated to the education of boys and founded several colleges on the island. Deodat, inspired by the grotto at Lourdes, embarked on a building project which would span several decades. The first version of the chapel, measuring just 9 feet by 4.5 feet, was pulled down within a day as Deodat has received criticism for its small size! Soon after, Deodat completed a second, larger version but even though, at 9 feet by 6 feet, it was larger than it's predecessor, it was destroyed in 1923 after the Bishop of Portsmouth was unable to fit through the doorway. And so the building of the third and final version began. The main shell of the building, now measuring 16 feet by 9 feet, took just two years to complete. However, the decoration would continue for many, many years. Deodat struggled to find enough resources to complete the task until after the chapel was featured in the *Daily Mirror* in 1925. He was soon inundated with donations of materials from around the world. Sadly, due to ill health Brother Deodat was unable to finish his project, and he returned to France just before the Second World War. Another member of the order, Brother Cephas, took over the decoration of the Little Chapel until his retirement in 1965.

The Little Chapel is a very popular attraction for both visitors and locals, and it never fails to impress. It is a beautiful part of the landscape and its form and colours can be admired from some distance. Yet it is when you get up close that you can

really appreciate the intricacy and variety of all the individual pieces that make up this unique landmark. Renovation work undertaken recently has ensured that the Little Chapel can continue to be enjoyed and appreciated by future generations.

https://www.thelittlechapel.gg/

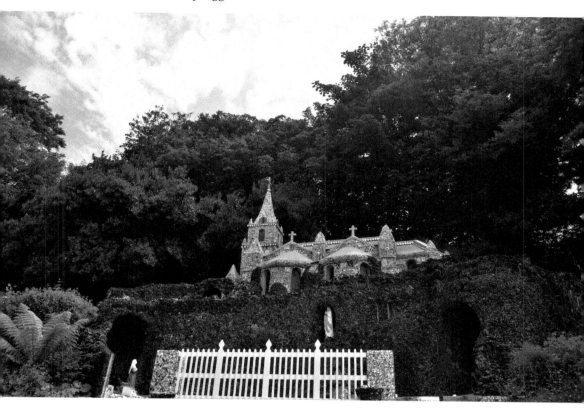

Above and right: The Little Chapel. (Soo Wellfair)

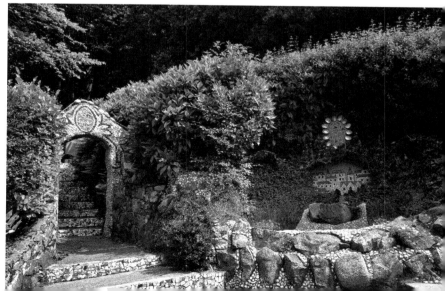

19. The German Underground Hospital

La Vassalerie, St Andrew, GY6 8XL

If atmosphere is what you are looking for, then a visit to the German Underground Hospital is an absolute must. It has been open to the public as a visitor attraction since 1954 and was taken over by Festung Guernsey in 2018. Festung Guernsey are a group of enthusiasts who excavate, restore and maintain an array of fortifications around the island, with the ultimate goal of making them more accessible to the public.

The hospital is a vast network of tunnels covering an area of 75,000 square feet and was built by forced labour workers during the German Occupation. It is thought that the workers excavated around 30,000 cubic metres of rock in the construction of these tunnels. Initially designed to be a personnel shelter, it was later decided to convert it into a hospital and ammunition store, and was mostly completed by spring 1944. It was largely unused as a medical facility during the Occupation and after a number of patients were admitted after the war ended, they were soon relocated as the conditions were not suitable for those in poor health.

Other than improvements made recently by Festung, the hospital has been left as it would have been at the end of the Occupation. Because of this, it has a feeling of almost being suspended in time and evokes a sense of poignant nostalgia not normally achievable in a modern museum. The site is also being used in new and inventive ways, and is fast becoming a popular venue for live entertainment events.

http://www.germanundergroundhospital.co.uk/

The German Underground Hospital. (Festung Guernsey)

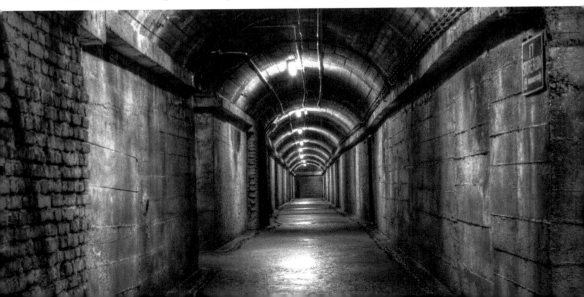

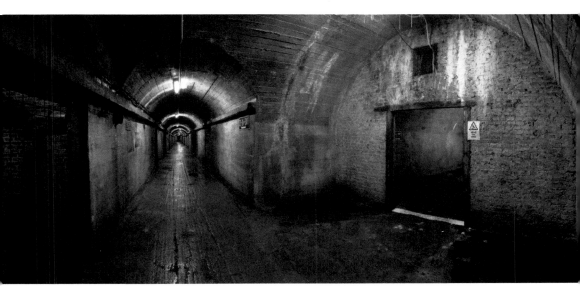

Above and below: The German Underground Hospital. (Festung Guernsey)

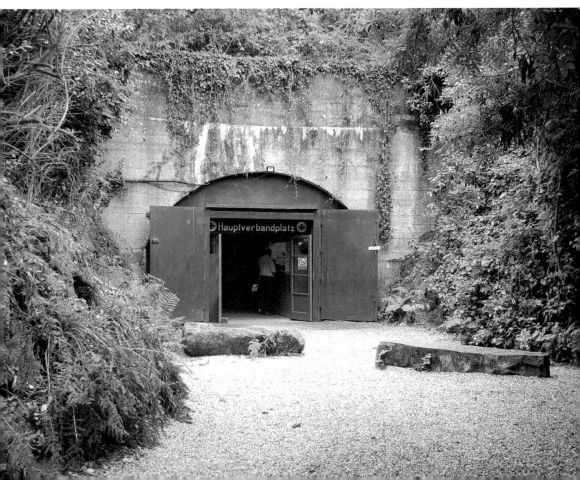

Forest

20. Les Caches Farm

Les Villets, Forest, GY8 0HN

Les Caches Farm is a cluster of traditional buildings looked after by the National Trust of Guernsey.

Most notable is the fifteenth-century thatched barn, which was lovingly restored as part of an extensive heritage project.

The barn and outbuildings are open to the public and are also available to hire for private events. The grounds of Les Caches Farm are open all-year round. The barn houses some fascinating traditional Guernsey farmhouse features, such as a

Restored Guernsey farmhouse at Les Caches Farm. (Soo Wellfair)

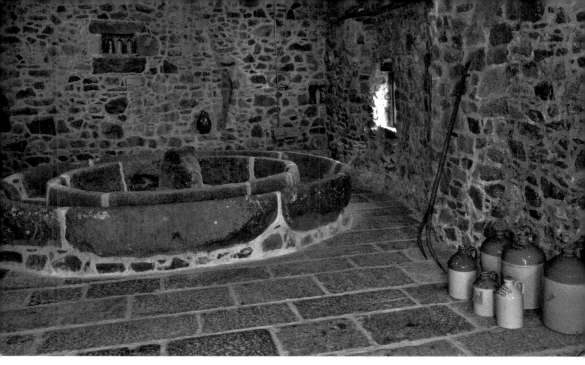

tourelle (a spiral staircase encased within a tower), a furze oven and a stone apple crusher.

In 2017 an orchard was planted in the grounds, as the site has been identified as once being part of Guernsey's cider industry, back when it was a working farm. The grounds are not just beautiful but they also play an important part of the island's biodiversity. The reed beds at Les Caches are considered of great significance in particular.

Situated at the top of Le Gouffre valley, Les Caches Farm is the perfect spot to visit as part of a local walk. It is close to several areas of National Trust land, as well as being just a short walk from the island's scenic cliff paths.

https://www.nationaltrust.gg/places-to-visit/les-caches-farm/

21. German Occupation Museum

Les Houards, Forest, GY8 0BG

If you have an interest in social history or the Occupation years, then you simply must visit the German Occupation Museum, which houses the most extensive and varied collection of Occupation exhibits in Guernsey. It is a private collection, built up over many years by owner and founder Mr Richard Heaume. Richard started

his collection as boy back in 1966 and his museum has expanded over the years, becoming a veritable treasure trove of Occupation items. Many items are rare and give a unique insight into time, such as how people lived, the transportation they used, plus areas dedicated to the stories of deportation and persecution of Guernsey Jews.

Some of the highlights of the museum include an Enigma secret coding machine, a full-sized fire engine and an exhibition dedicated to the Biberach internment camp. The Biberach room has some wonderful examples of items handmade by Channel Islands internees, including an extremely intricate, miniature cooking stove made from mostly Red Cross tins. One of the most popular areas of the museum is 'Occupation Street', where a street in Guernsey has been recreated to reflect how it would have looked during the Occupation years, complete with cobbled paving and shop facias.

The museum is open daily (check website for seasonal opening hours) and has a small tearoom providing refreshments.

www.germanoccupationmuseum.co.uk

The German Occupation Museum. (Soo Wellfair)

The following text appears on a sign within the image:

GERMAN SEA MINE type OZ.
One of hundreds, laid against
Allied shipping around the
Channel Islands.
On June 11th 1943, two
Guernsey fishermen were blown
up by a similar mine off Herm.

Above and below: The German Occupation Museum. (Soo Wellfair)

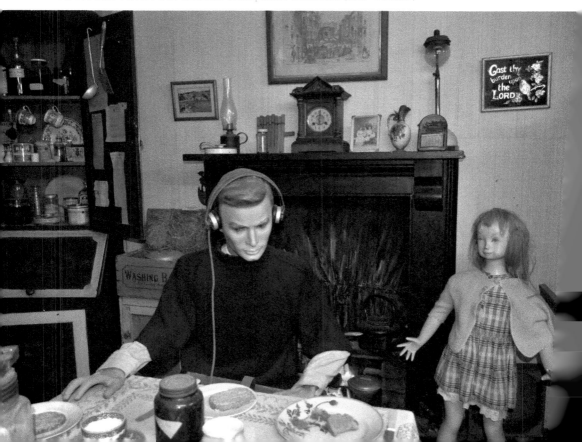

22. Lihou Island

Access from the L'Eree headland, Rue du Braye a Lihou, St Pierre du Bois, GY7 9LR

Lihou is a tidal island only accessible by a causeway at certain times during a low spring tide. It is an area of stunning natural beauty, with an abundance of wildlife and breathtaking scenery. It was built in 1840 by the occupier at the time, James Priaulx, to enable him to transport large amounts of vraic (seaweed) over to Guernsey to sell. Not only was vraic a valuable commodity as fertiliser, it was also a useful source of iodine.

As you walk along the causeway, you'll notice many natural rock pools that run along either side. The marine life around the island is fascinating and varied and Lihou is classified as an official RAMSAR site. This means it is recognised as a wetlands area of significance. Wetlands areas are a really important part of the ecosystem, and you will find a number of species thriving in the waters around Lihou. You may be lucky enough to spot sea urchins, starfish, squat lobsters, various anemone, crabs and the famous Guernsey ormer. An ormer is a type of sea snail, likened to the more well-known abalone. It is considered a delicacy in Guernsey and there are strict harvesting regulations in place.

The house you see today was built in the 1970s in the same spot where the original farmhouse stood, before it was destroyed during the Occupation. Although not open to visitors on a daily basis, the house is in the care of a charitable trust who organise a variety of events in the house and its grounds throughout the year. It is also possible for large groups to book a stay in the house. In the walled garden there once stood the iodine factory mentioned earlier. It too was destroyed when used as target practice during the Second World War.

One of the most fascinating sites on Lihou are the remains of the old priory. Even in ruins it is a beautiful spot to take a rest and enjoy the splendour of your surroundings. The priory was built by Benedictine monks in the twelfth century. It came as a direct challenge to pagan worshipping, which was taking place across the causeway at Le Catiaroc in Guernsey. Excavations of the area over the years have uncovered pottery, glass, ornate metal objects, coins and a number of graves. Lihou is of great archaeological importance, particularly since digs in the 1990s uncovered

evidence from the Mesolithic era (around 7500 BC). The priory fell out of use after the Reformation, when Henry VIII ordered the Dissolution of the Monasteries.

As you reach the north-west side of Lihou, you will find the access point to the beautiful Venus Pool. The Venus Pool is effectively a huge rock pool which fills with sea water, creating a delightfully tranquil swimming pool. To access it there is a fair amount of rock clambering involved, and tidal times need to be monitored carefully, but it is certainly worth the effort.

https://www.gov.gg/lihou

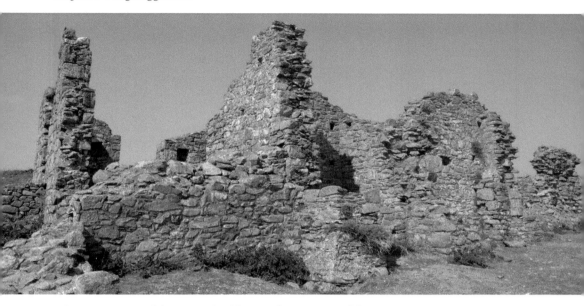

Above: Remains of the priory buildings, Lihou. (Soo Wellfair)

Below: The house on Lihou. (Soo Wellfair)

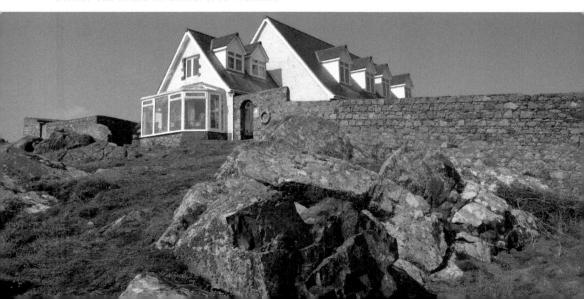

23. The Observatory

Rue du Lorier, St Pierre du Bois, GY7 9JU

Guernsey, with it's clear skies and low levels of light pollution, is the perfect place to practise astronomy as visibility is far better than in the UK. It is even possible to view the Milky Way with the naked eye on a clear evening. There are many spots, particularly around the west coast, where it is possible to view and photograph very dark skies on a clear night when there is no bright moon. Dark skies are measured on a scale known as the Bortle scale. The scale goes from one to nine and the darkest skies in the world register at number one on the scale. Guernsey actually registers as number two on the scale, meaning it has very low levels of light pollution.

The astronomy section of La Société Guernesiaise was founded in 1972. Members meet up regularly and enjoy many benefits including use of the equipment and the on-site library as well as being given the opportunity to attend various events and lectures. Guernsey has its own fully equipped observatory, complete with a roll-off roof and installed with a vast array of astronomical instruments.

The observatory is open to the public on certain evenings of the year, at organised events and courses and by private arrangement. The annual 'Star Gazing' course, which run over six weeks each spring, is very popular with those interested in taking up this fascinating pastime.

www.astronomy.org.gg

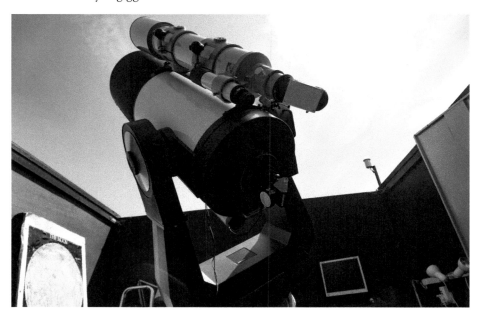

The Guernsey Observatory. (J. M. Dean)

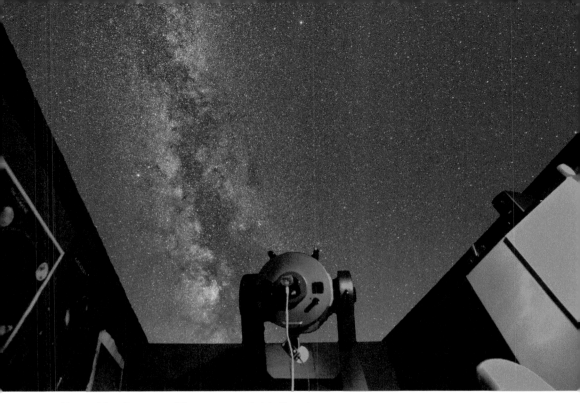

Above: The Guernsey Observatory. (J. M. Dean)

Below: The Milky Way over Petit Bot. (J. M. Dean)

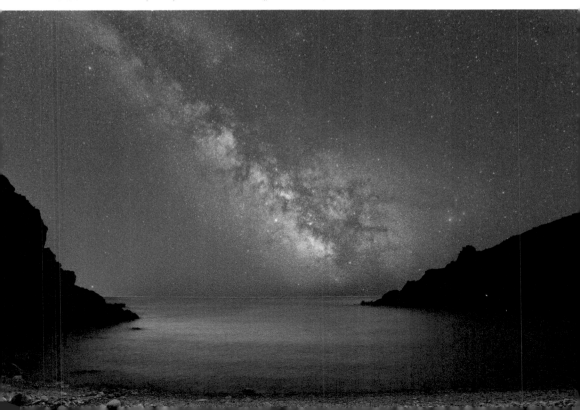

24. Le Tricoteur Guernsey Factory

Route de Rocquaine, St Pierre du Bois, Guernsey, GY7 9HS

Going back around 400 years, the traditional thick, woollen jumper known simply as the guernsey is almost as famous as the island itself! Originally created for fisherman to stay warm and dry out at sea, these garments quickly became popular all over the world, and they are still highly sought after today. The guernsey is well-made, hard-wearing and comfortable. Both practical and stylish, the humble guernsey is a timeless classic. The iconic pattern has some rather quirky design features, including specific stitches to represent the garment's maritime roots, such as rope ladders, waves and pebbles. Certain stitches and patterns were used to identify specific families, which helped identify those sadly lost at sea.

The traditional guernsey was made in navy blue and was originally hand-knitted in one piece. There are various ways of knitting the guernseys these days, using both modern and traditional methods. They are also now available in a wide array of colours and are available in various outlets across the island.

One of these is Le Tricoteur, a small factory based on the west coast. Le Tricoteur still use traditional hand-finishing methods and each item is signed by the knitter who completed it. A number of core members of staff have been working for the company for forty to fifty years and whilst the ownership has changed hands over the years, it is now back in the hands of the family which founded Le Tricoteur in the 1960s. Le Tricoteur use worsted wool in their guernseys and the result is a stronger, more resilient product, capable of keeping out the wind and rain and keeping its shape perfectly. A guernsey

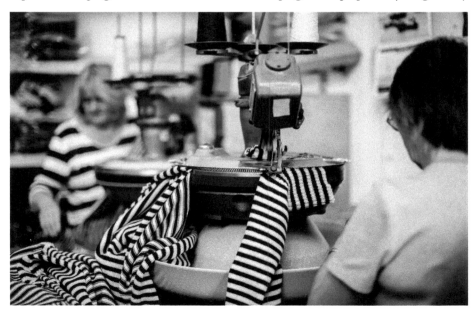

Le Tricoteur factory. (Etienne Lainé)

should last a lifetime and that is what makes it popular with guernsey wearers both locally and across the globe. Le Tricoteur sticks faithfully to traditional manufacturing processes and styles, yet they are also innovative and are able to meet the fashion demands of the modern consumer. There is an on-site factory store which is open to the public and it is worth contacting them to see if they have any upcoming tours planned.

https://letricoteur.co/

25. Le Creux és Faies

La Rue du Braye, St Pierre du Bois, GY7 9LW

Do you believe in fairies? Then you must visit Le Creux és Faies, a Neolithic burial chamber believed to be the magical gateway to Fairyland! According to local folklore, the door to the kingdom of the fairies can be found at the back of this prehistoric dolmen. Fairy legends go back centuries in Guernsey and you will find both local fairies (known as pouques) and more exotic fairies (from Fairyland) all over the island, particularly around little caves and prehistoric sites. In fact, it is said that Guernsey people descend from fairies, after an invasion led to a whole army of fairies taking local girls for their wives and having families. Another legend tells the story of how the Creux és Faies was once a popular meeting place for witches who congregated there, as well as another local dolmen, Le Trépied, on the witches' sabbat.

The passage grave itself dates back to somewhere between 3000 BC and 2500 BC. It was excavated in 1840 and some of the archaeological finds included arrowheads, pottery, and animal and human bones. It is possible to take a look inside the tomb, which is surprisingly spacious. Located on the L'Eree headland, it is within walking distance of the Lihou causeway and the coastal path which stretches along the west coast.

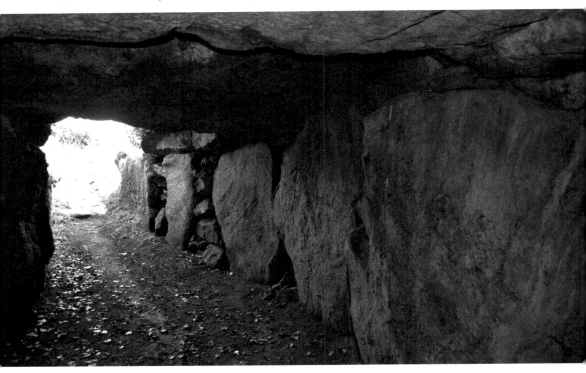

Above and left: Le Creux és Faies. (Soo Wellfair)

26. Pleinmont Observation Tower

Pleinmont headland, Torteval (parking at La Rue du Chemin Le Roi, GY8 0PZ)

Also known as the MP3 Tower, this is one of six *Marinepeilstande* built in Guernsey during the Occupation. The name translates to marine directional finder and is one of many fortifications built by the occupying forces during the Occupation. These large towers dotted around the coastline are a poignant reminder of the war years and the fortifications in this area in particular have become quite iconic over the years, and have been featured on the cover of many publications about the Second World War and Hitler's 'impregnable fortress'.

Located in the Pleinmont area, the MP3 Tower can be easily reached by car but it is much more gratifying to incorporate it into a walk, following the cliff paths from either direction. The area is elevated and extremely beautiful. The views out to sea are stunning and Pleinmont itself is rural and boasts some fabulous walks through National Trust land. The area is awash with historical sites as well as natural beauty.

The observation tower has been set up as a museum and is usually open to visitors from April to October on occasional afternoons (check website for opening hours). It is a fascinating insight into these fortifications and their construction and you can admire the amazing views even more from the roof of the tower, which can be accessed during normal opening hours.

Just a short walk from the tower you will find an impressive restored gun placement called Batterie Dollmann. Much of the site is underground, including ammunition bunkers and personnel shelters, and the site is occasionally opened to the public and organised groups.

www.visitguernsey.com/see-and-do/things-to-do/pleinmont-observation-tower

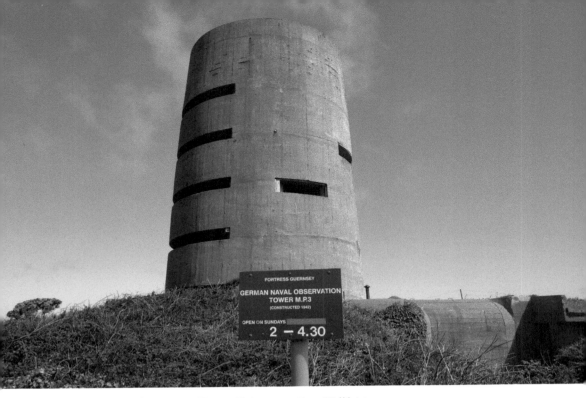

Above: MP3 Observation Tower, Pleinmont. (Soo Wellfair)

Below: Batterie Dollmann, Pleinmont. (Soo Wellfair)

27. La Table des Pions/ The Fairy Ring

Rue de la Varde, Torteval, GY8 0NA

Les Tables des Pions translates to the 'footmen's table' and is a circular table cut into the ground. It was created as part of a tradition known as La Chevauchee. La Chevauchee was a procession that took place every three years, to ensure that all paths around the island were clear so that any passing dignitaries could get by without obstruction. However, it is thought this tradition was actually started by the Abbot of Vale church, and the procession took place to ensure his yearly walk around the island to give the holy sacrament would go smoothly. Either way the Table des Pions was a later addition, probably late eighteenth century.

It is more commonly known locally as the Fairy Ring. Guernsey has a rich history of folklore, and legends and fairies feature quite heavily in these tales. It is believed that there are many enchanted caves dotted along the coast of Guernsey that act as gateways to magical fairy lands. The Fairy Ring is one of the places these mythical creatures like to visit and legend has it if you walk around the Fairy Ring three times you may be granted a wish. Why not have a try?

One of the most popular routes up to the Fairy Ring is to walk up the road from Portelet, although you can also reach it by following the cliff path from Pleinmont.

La Table des Pions/The Fairy Ring. (Soo Wellfair)

La Table des Pions/The Fairy Ring. (Soo Wellfair)

28. Fort Grey

Route de la Lague, Torteval, GY8 0QE

Fort Grey is a truly spectacular-looking part of the west coast landscape. This early nineteenth-century coastal defence is one of just three of its kind in Guernsey and it is certainly the most striking in appearance. The bright white tower and surrounding outer wall has led to Fort Grey being nicknamed 'The Cup and Saucer'. It is built on the site of the former Chateau de Rocquaine and is now home to Guernsey's shipwreck museum.

The seas around Guernsey are rough and rocky and many ships have been lost in these dangerous waters over the centuries. In 1807 HMS *Boreas* was wrecked off the Hanois Reef. This terrible disaster, which resulted in the loss of most of the crew, led to a public call for a lighthouse in the area. The Hanois Lighthouse was opened in 1862. The cannon from the *Boreas* was salvaged from the wreck and is on display at Fort Grey, where it is pointed towards the Hanois Reef in memory of the lives lost. There is also a marvellous 1-metre-high model of the Hanois Lighthouse in Fort Grey, with a lantern which flashes in synchronisation with the full-sized lighthouse.

The museum is open to the public from March to November and is one of four sites in Guernsey where the Discovery Pass can be used.

http://www.museums.gov.gg/article/101090/Fort-Grey

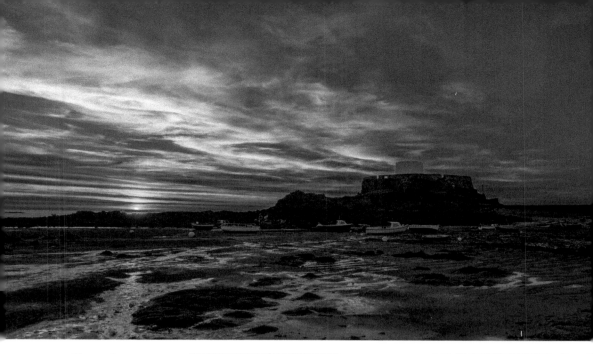

Above: Fort Grey.
(J. M. Dean)

Right: Inside Fort
Grey Shipwreck
Museum. (Guernsey
Museums &
Galleries)

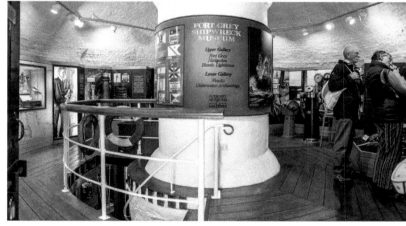

Aerial view of Fort
Grey. (Guernsey
Museums &
Galleries)

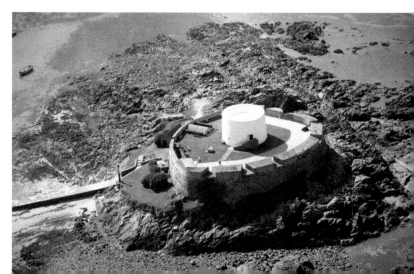

29. Torteval Scarecrow Festival/ Torteval Parish Church

Torteval Church, Rue de Belle, Torteval, GY8 oLN

Since 2004, every year for just two days the quiet parish lanes of Torteval are transformed into a walking trail of scarecrows! Torteval residents are all invited to submit an entry into the popular annual competition, which sees thousands of people follow the trail and voting for their favourites. There are a variety of prizes up for grabs and the standards are incredibly high. Most years there are between fifty to sixty scarecrows on display of various sizes and styles, and many will have a topical or political theme, reflecting on what has been happening in Guernsey that year.

The walk takes around one and a half hours and takes you around some of the most beautiful and tranquil lanes in the area. The neighbouring fields are used to put on something of a country fayre during the scarecrow festival, with various tents and stalls, live music and refreshments. Many people take a picnic with them and make a day of it.

Each year the festival begins at the Torteval parish church, which itself is well worth a visit. Torteval church is really quite unique with its narrow, circular tower and tall steeple. In fact, Torteval church has the tallest steeple in Guernsey, which doubles up as a sea marker! The current church, built in 1816, replaced an earlier eleventh-century church which had fallen into disrepair. The bell of Torteval church is actually much older than the church itself and was cast in France in 1432, making it the oldest bell in the Channel Islands.

www.facebook.com/tortevalscarecrowfestival

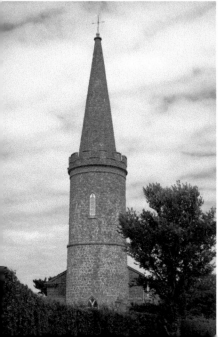

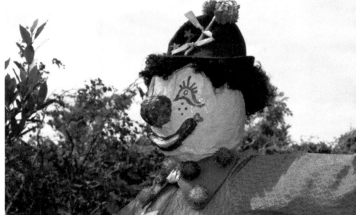

Above: Torteval Scarecrow Festival. (Soo Wellfair)

Left: Torteval Parish Church. (Soo Wellfair)

30. Bruce Russell & Son, Goldsmith and Silversmith

Established in the early 1800s and going back four generations, Bruce Russell & Son is a Guernsey gold and silversmith using traditional methods that have made them famous worldwide. With a long list of impressive commissions over the years, including royalty and heads of state, Bruce Russell & Son continues to produce beautiful items of exceptional standards at their workshop in St Saviour.

Bruce Russell & Son, Gold and Silversmith. (Soo Wellfair)

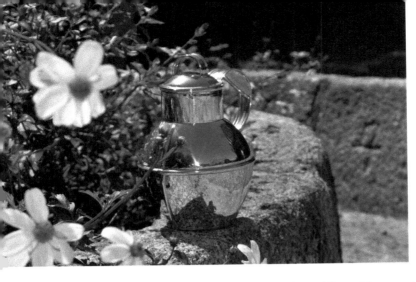

A traditional
Guernsey Can
in silver. (Soo
Wellfair)

The showroom and shop are open to the public, with some lovely examples on display, such as the world-famous Guernsey milk can and christening cup. Visitors are invited to enjoy the delightful gardens and nature reserve, stretched over some 8 acres of rural beauty. You can also visit Le Gron Menhir, an ancient standing stone which promises good fortune to those who walk around it once and put their finger in the stone's hole!

With a restaurant on-site, it is a fabulous place to visit and explore. There are some interesting features to look out for including an old cider press and a traditional witch's seat. Steeped in folklore, Guernsey has some very unusual traditions. The witch's seat is a plinth built into traditional Guernsey farmhouses, usually beneath the chimney. Legend has it, these were added to homes as a place for weary witches to rest so they would not be tempted to fly down the chimneys instead!

www.bruce-russell.com

31. St Saviour's Reservoir

Rue a L'Or, St Saviour, GY7 9XS

The reservoir in the parish of St Saviour is a stunning and peaceful setting, providing both freshwater and woodland habitats for a wide variety of species. In fact, it is the largest area of freshwater in Guernsey. The reservoir was created by building a dam and flooding three valleys and a small village in the area. At times of drought, when the water levels are extremely low, it is possible to see the remains of some of the buildings which stood in the area before it was flooded.

The best way to explore the reservoir is to follow the Millennium Walk. This is a 3-kilometre trail which takes you all the way round the reservoir itself and through the lush woodlands and takes approximately one hour. The views along the way are beautiful and you might be lucky to spot kingfishers, cormorants, sparrowhawks,

herons, long-eared owls or wagtails on your route. The reed beds act as a natural filter for the water and also provide the perfect conditions for nesting birds.

As well as being a popular place for walkers, wildlife enthusiasts and fishermen to visit, the reservoir also has a very practical purpose. Holding 240 million gallons of water, it provides around 25 per cent of the island's stored water.

The circular route around the reservoir is perfect for families as there are several geocaches hidden along the way. If you are not familiar with geocaching, it is a fun, modern version of a treasure hunt, where small boxes (known as caches) are hidden with GPS co-ordinates provided to be found via the geocaching website or app. The caches usually contain a log to write your name in and quite often small items to trade. There are also a number of wildlife-themed brass rubbing plaques placed around the route, so make sure to take some crayons and paper.

www.geocaching.com/

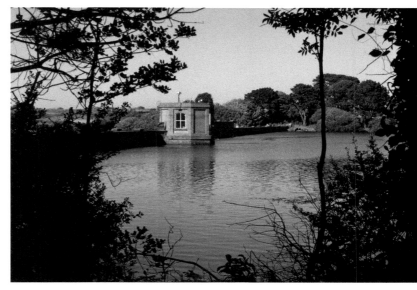

St Saviour's Reservoir. (Soo Wellfair)

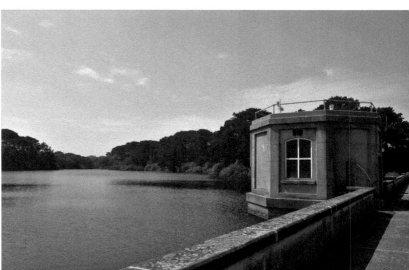

32. St Apolline's Chapel

La Grande Rue, St Saviour, GY8 0DS

Around a twenty-minute walk from the St Saviour Reservoir, St Apolline's is a small chapel with a very interesting story and is named after Saint Apollonia. Apollonia was a Christian deaconess in the third century. Living under Roman rule in Alexandria, she was punished for providing shelter for persecuted Christians. She was beaten so badly that all of her teeth were either broken or knocked out, and when soldiers threatened to throw her onto a fire if she did not denounce her faith, she threw herself into the flames. She was made a martyr and became Saint Apollonia, patron saint of dentists. There is a window in the chapel dedicated to her, which depicts her being looked over by an angel holding a tooth.

The chapel was built in the late fourteenth century, then fell out of use after the Reformation. It was used as a stable until it was purchased in the late nineteenth century by the States and is now a protected building. It is an attractive building that can accommodate around sixteen worshippers at one time. Some of the most unique features within the chapel are the medieval frescos depicting the Last Supper and Jesus washing the feet of the Apostles. These historical works of art are extremely rare and part of what makes this little chapel a very special place to visit.

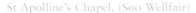

St Apolline's Chapel. (Soo Wellfair)

Above: Wall fresco inside St Apolline's Chapel. (Soo Wellfair)

Right: Stained-glass window depicting Saint Apollonia. (Soo Wellfair)

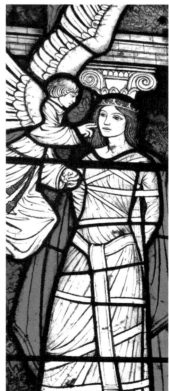

Castel

33. Saumarez Park

Saumarez Road, Castel, GY5 7UJ

Saumarez Park is Guernsey's largest public park and is open all-year round. The park is popular with all ages as it offers a wide variety of experiences. The main area of the park is a large open lawn which lends itself well to some of Guernsey's most treasured events, such as the Viaer Marchi, the North Show, Battle of the Flowers and the Donkey Derby. The park boasts a wide variety of species of trees, shrubs and flower beds, and has a dedicated rose garden with a beautiful oak pergola.

Rose garden and pergola at Saumarez Park. (Soo Wellfair)

The Victorian Walled Garden gives a snapshot of how fruit, vegetables and flowers were cultivated during the Victorian era, and the volunteers grow only produce which is appropriate to the time period. There is a small shop on-site where this produce can be purchased.

The National Trust Folk and Costume Museum is also based in Saumarez Park and is a fascinating way to learn about Guernsey's social history. There is also a delightful shop within the museum which is transformed into the Museum Christmas Shop every winter.

The courtyard is often used as an open-air music venue during warmer months, as well as being the home of a popular annual vintage tractor show. Also within the grounds there is an adventure playground for children, a well-populated duck pond, an outdoor exercise area and a cafe. There is also a nature trail which leads from the park to Cobo, on the west coast. It is a lovely, peaceful woodland walk, with some interpretation boards along the way advising the reader of what wildlife can be spotted in the area.

www.walledgarden.gg
www.nationaltrust.gg/places-to-visit/folk-costume-museum-saumarez-park

34. Cobo and Vazon Bay

Cobo and Vazon coast roads, Castel

Cobo and Vazon are two of the most popular beaches along the west coast and are within walking distance of one another.

Cobo is very popular with families, who spend the day enjoying the beautiful sandy beach and crystal clear, shallow waters. At low tide the beach is vast and in the summer will be dotted with sunbathers, sand castle builders and those enjoying beach games. Cobo is also known for being the perfect spot to watch the sun go down, and the most popular way to do this is with a bag of chips from the local chippy or from one of Cobo's pubs, hotels, kiosks or restaurants which overlook the bay. In the summer months Cobo is often used as the venue for a number of live music events, known locally as 'balcony gigs'. During these events a section of the coast road is closed to traffic so music lovers can listen to live music and dance the

Cobo Bay. (Soo Wellfair)

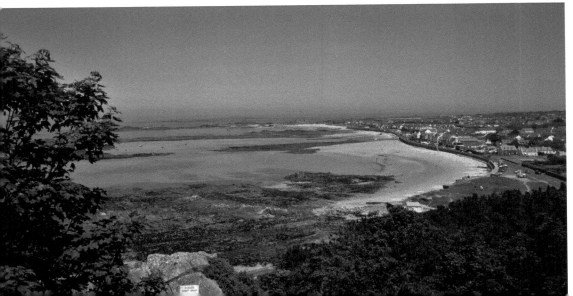

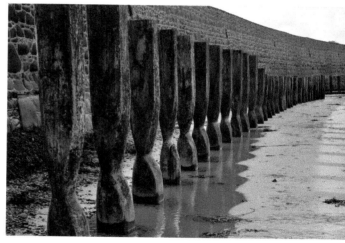

Above: Vazon Bay.
(Soo Wellfair)

Right: Wooden groynes at Vazon
Bay. (Soo Wellfair)

night away. The area has also been used over the years to host a number of open-air cinematic events, with popular movies projected onto large screens.

A little further along the coast you will find Vazon Bay. This is another beautiful, unspoilt beach with a more sports-orientated clientele. The waves at Vazon are very popular with surfers, paddleboarders, windsurfers and other water sports enthusiasts. Vazon beach is also the home of sand racing, which attracts large crowds of spectators. Again, the bay is well facilitated with some great places to eat and drink nearby. After very stormy weather and at extreme low tides, the remains of a petrified 10,000-year-old forest is occasionally uncovered on Vazon beach, which is quite an amazing sight to behold.

35. Fort Hommet

Fort Hommet Headland, Vazon, Castel

Fort Hommet is an excellent example of a coastal defence that has been continually modified and adapted throughout the centuries. This site has been fortified since the seventeenth century, possibly earlier. The Martello tower, which is one of only three on the island, was built in 1804, at a time when Guernsey was extremely vulnerable to French attack. Barracks and additional batteries were added during the nineteenth century and it was heavily fortified by the occupying forces during the Occupation. The site is open and accessible to the public and has ample parking just a short walk from the main fortification. One of the German gun casement bunkers has been restored and is open to the public during the summer months on Saturday afternoons.

Another bunker, named the Shrine of the Sacred Heart, is also open on certain dates across the summer. It was constructed in 1960 by Hubert Le Galloudec who decorated the interior with hundreds of shells. He had asked permission to clear the bunker after pledging to create a place of peace out of a remnant of war. After a long period of abandonment, the shrine was restored and reopened in 2008. Entrance is free but charitable donations to help with the upkeep of the shrine are welcomed. It is taken care of by a group of volunteers who are available on open days to answer any questions visitors may have about the shrine and its history. Within the bunker there is another room which displays press articles and a photo archive. There is also an audio tour which can be played through loudspeakers as you make your way through the shrine, which details the background and restoration of the site. There

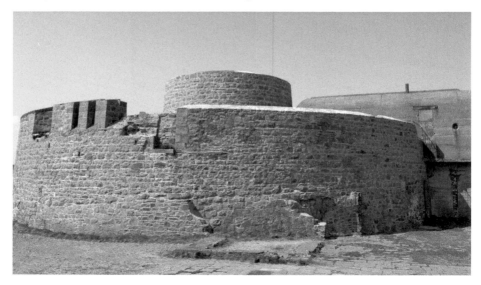

Fort Hommet. (Soo Wellfair)

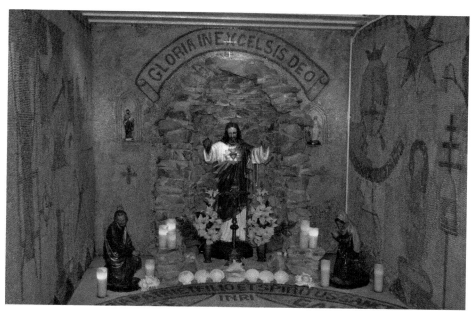

Inside the Shrine of the Sacred Heart at Fort Hommet. (Soo Wellfair)

is also a DVD of old news footage relating to the shrine. The shrine itself is a unique piece of art and an absolute joy to behold.

https://sacredheart.org.gg/

36. The Guet

Le Guet, Cobo, Castel

Something you may not expect to find in Guernsey is a pine forest! The Guet is an elevated woodland area overlooking the west coast and is a fabulous place for walking, exploring, geocaching and picnicking. Situated high above Cobo and offering spectacular views, The Guet is well worth a visit. The forest is dominated by non-native Monterey pines, which were planted in the late 1920s. However, these pines have a limited lifespan and indigenous trees are being slowly introduced to replace them over time, to help improve the biodiversity of the area. The Guet is popular with wildlife enthusiasts and is a wonderful habitat. Long-eared owls and pipistrelle bats are often spotted in the area.

Look out for the Napoleonic watch house nestled within the forest. Built in 1780, it was used as a lookout point with amazing views across the west and out to sea.

You can see this for yourself if you climb up to the viewing point which is now located where the watch house still stands. The word 'Guet' actually means 'watch' in Guernesiase.

You will find the lower entrance to The Guet directly opposite the car park by Cobo beach. There is also a delightful beach kiosk nearby where you can enjoy some delicious refreshments.

Above: The Guet.
(Soo Wellfair)

Left: The watch house at The Guet. (Soo Wellfair)

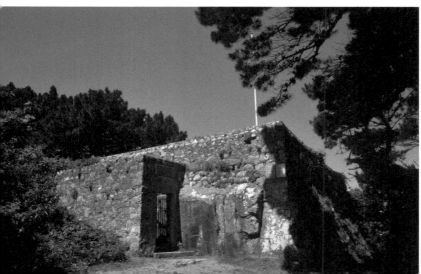

37. Rocquette Cider Farm

Les Fauxquets de Hauts, Rue des Fauxquets, Castel, GY5 7QA

The history of cider in Guernsey goes back as early as the sixteenth century, and traditional Guernsey cider presses have become quite a popular ornamental feature in gardens around the island. There is also a nice example at the Folk and Costume Museum if you'd like to get a closer look.

There is now just the one commercial cider maker in Guernsey, based in the heart of the beautiful Fauxquets Valley. This is the home of Rocquette Cider, established in 1998. Although they use a more modern approach to manufacturing, they still embrace traditional cider farm ways. They are a family-run business, still based at the farm where the family lives and works. The cider farm produces a variety of ciders, liqueurs and spirits, apple juice and chutneys and have installed a still to produce small-batch cider brandy. They even still keep the traditional Wassail ceremony going, which involves singing and dancing around the orchards and banging sticks together to ward off bad spirits.

Rocquette Cider Farm. (Soo Wellfair)

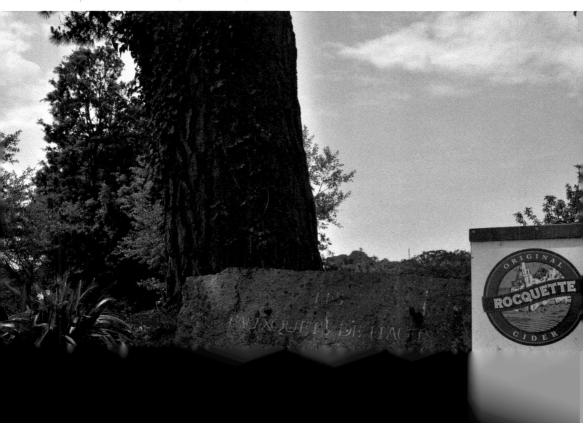

Rocquette Cider Farm. (Soo Wellfair)

The farm holds public tours on specific dates throughout the season as well as taking private bookings. The tours involve a walk around the stunning orchards, a look behind the scenes and usually a few delicious tasters. Set in rural valleys in the parish of Castel, the surrounding area is perfect for walking and exploring.

www.rocquettecider.com

Vale

38. Rousse Tower

Rousse headland, Vale

In the late eighteenth century, fifteen loophole towers were constructed to protect Guernsey's coastlines from French invasion. They were manned by the Royal Guernsey Militia, which was made up of local men. It was largely made up of farmers and fisherman and service was expected on top of a full-time job elsewhere. Service was unpaid and compulsory at times of war. It was not unusual for a member of the militia's family to cover his night shifts if he had work the next day.

Rousse Tower. (Soo Wellfair)

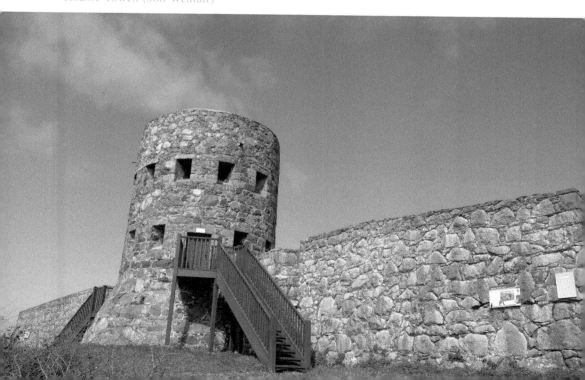

Gun platform at Rousse Tower. (Soo Wellfair)

There are twelve of these towers left in Guernsey and this is loophole tower number eleven. Rousse Tower has been restored and transformed into a 'mini museum' with replica cannons installed outside, information boards and a small display inside the three-storey building. The opening hours can be limited, so check online before visiting. At times when the inside is closed to the public, it is still possible to explore much of the site.

From the top of this west coast tower it is possible to see Victoria Tower, which is situated in St Peter Port in the east. This and other landmarks are highlighted on a useful panoramic interpretation board.

The Rousse headland is an area of great beauty and the coastal path runs straight past the tower, so it is the perfect place to pause if you are taking a walk. There is also a fantastic kiosk nearby where you can enjoy refreshments and the nearby jetty is very popular with swimmers.

https://www.visitguernsey.com/see-and-do/things-to-do/rousse-tower

39. Vale Castle

Castle Road, Vale, GY3 5TX

In the north of the island, overlooking the parishes of Vale and St Sampson, you will find Vale Castle. It is thought that the castle was built in the late fourteenth or early fifteenth century as a place of refuge in times of invasion. Vale Castle stands in an area once known as the Clos du Valle, which up until the early nineteenth century was actually separated from the rest of Guernsey by a stretch of water known as the Braye du Valle. Although the castle was unlikely to have been intended for military purposes, it has been regularly garrisoned over the centuries.

During the First World War barracks were built, which later became social housing, with many local families living there until they were destroyed during the Second World War. With no electricity, gas or running water, it would not have been a terribly comfortable place to live. There is not much left of Vale Castle in terms of interior buildings and the castle has not been modernised in any way. But this is part of its charm and is a wonderful site to explore, offering amazing views; much of the island's history can be seen here. The castle was heavily fortified during the Second World War and there are many interesting structures from the Occupation years dotted around the grounds.

Vale Castle. (Soo Wellfair)

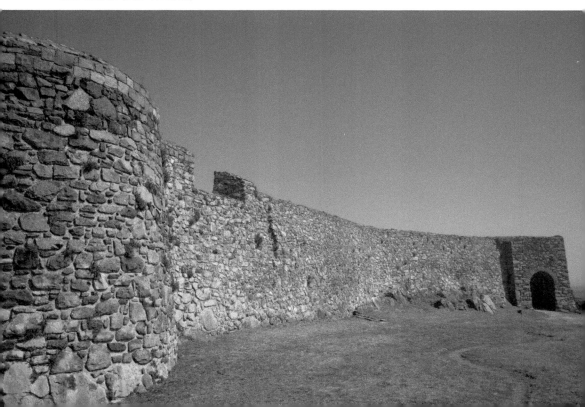

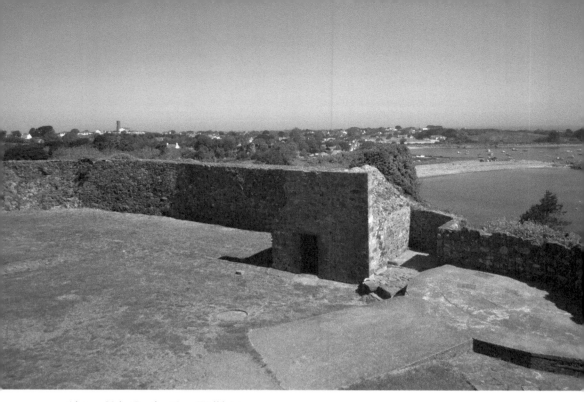

Above: Vale Castle. (Soo Wellfair)

Below: Cemetery at Vale Castle. (Soo Wellfair)

One of the most unusual features of Vale Castle is a tiny cemetery with a very interesting story and a number of German fortifications from the Occupation years. You can follow the coastal path further north and towards the west from Vale Castle, which is a beautiful and interesting route with many historical sites along the way, as well as kiosks, cafes and beaches to enjoy.

40. L'Ancresse Common

L'Ancresse, Vale

L'Ancresse Common is the largest area of open land in Guernsey and is found in the very north of the island in the parish of Vale. Much of the common runs alongside the beaches of L'Ancresse Bay and Pembroke Bay, which both boast beautiful stretches of white sand.

The common is home to two golf clubs and is also the location of the Guernsey parkrun, a weekly, free, timed 5-kilometre event.

L'Ancresse Common is also where you will find some of the island's most interesting prehistoric sites. With several Neolithic passage graves situated on the

L'Ancresse Common. (Soo Wellfair)

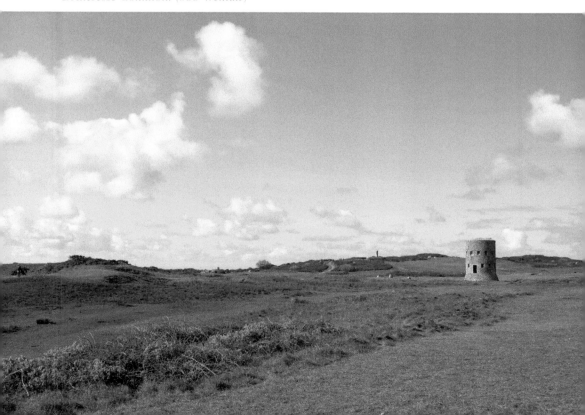

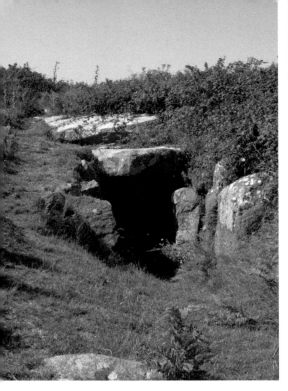
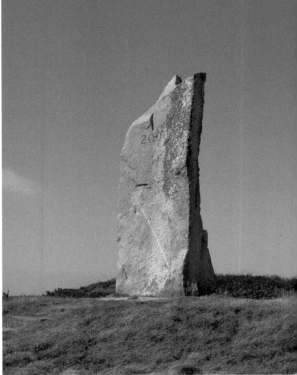

common, all of which are accessible and well preserved, you can absorb some of the island's fascinating pre-history in stunning surroundings. A more modern addition is the Millennium Stone, an enormous granite monument which sits atop one of the highest points of the common. The stone was erected to mark the turn of the new millennium in the year 2000.

In the spring you can enjoy the delightful scent of the gorse or furze, which covers much of the common and provides shelter for a wide variety of wildlife, including wild rabbits which can often be seen hopping across the golf course.

It is a wonderful place to take a walk and you can join the coastal path which continues towards the west of the island. There are plenty of kiosks and cafes/restaurants in the area for refreshments and the area is well-serviced by the local buses.

41. Dehus Dolmen

Le Dehus Lane, Vale, GY3 5EP

The Dehus Dolmen is one of the most impressive of the Neolithic passage graves on the island. It is one of the best-preserved prehistoric sites on the island and other

than the possibility of some of the stones being repositioned over the centuries, the structure is perfectly intact. A small entrance and low passageway leads you to a wider, higher main chamber with additional chambers either side. It is a circular structure made of granite stones, with a grassy mound on the outside.

During the excavations made by Frederick Lukis in the 1830s, the Dehus revealed some extremely interesting finds, including two human skeletons seemingly sitting back to back. This remains something of an archaeological mystery. The Dehus is also home to the 'Guardian of the Tomb', or *Le Gardien du Tombeau*. It's a Neolithic carving of a man, a bow and arrow and possibly symbols depicting animals around him. Now the challenge for you is to see if you can find him on one of the capstones. There is a light inside the chamber to help you locate him. It's thought that this stone may have actually originally been an upright stone but now forms part of the ceiling.

Located in the north of the island, the Dehus is near a popular bus route and just a short walk from the coastal path leading towards L'Ancresse, Pembroke, and round towards the west coast.

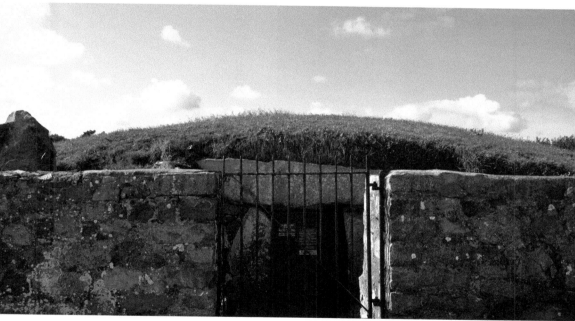

Above: The Dehus Dolmen. (Soo Wellfair)

Right: Le Gardien du Tombeau, the Dehus Dolmen. (Soo Wellfair)

St Sampson

42. Chateau des Marais

Ivy Castle Lane, St Sampson, GY2 4ZB

Chateau des Marais is a thirteenth-century stone-walled castle. In Guernsey French (Guernesiaise), *chateau* means house and *marais* means marsh. However, it is known locally as Ivy Castle, after it was abandoned for many years and became overgrown with ivy, before being restored fairly recently.

It is what is known as a motte-and-bailey castle. The motte is the raised mound on which the main building sits, and the bailey is a walled courtyard which is surrounded by a ditch.

Chateau des Marais. (Soo Wellfair)

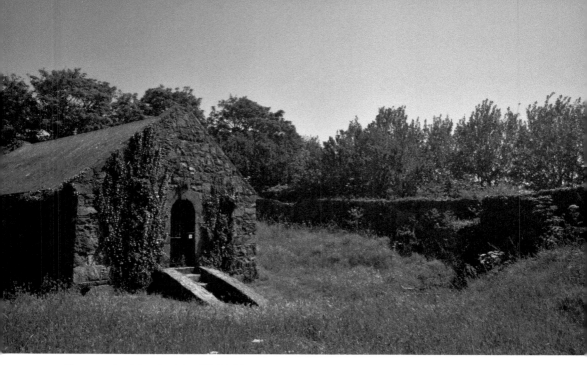

It was thought that it was originally built as a place of refuge from passing pirates and pre-dates Castle Cornet by twenty to thirty years, and would have been the island's main defensive structure during that short period of time.

During the Occupation some military modifications were made to the castle, causing considerable damage to the original motte-and-bailey structure. It is now a popular place for walkers and families and an interactive bug trail has been set up to encourage exploration of the site, which is a natural habitat for many species of insect. The trail can be accessed via a free app called Gamar. This site is completely tucked away, hidden behind a residential area. It really is a hidden gem, as even many locals haven't discovered it yet!

43. Oatlands Village

Les Gigands, St Sampson, GY2 4YT

Oatlands Village is one of Guernsey's most popular visitor attractions, and is tucked away in the north of the island. Although modestly sized, it boasts a variety of retail outlets including amongst others, a florist, a chocolatier, a craft shop, gift shop, pet store and a goldsmith.

It is a picturesque reminder of Guernsey's past with beautiful thatched barns and restored brick kilns, which go back to the days when Oatlands was a farm then a

brickworks. There are two large kilns at the main entrance which date back to the brick-making days of the late nineteenth century. The kilns were later used to make large clay pots, which became an integral part of Guernsey's famous tomato growing industry. There was actually a third kiln where the jewellery shop now stands. A small display and audio system have been set up in one of the old kilns with information about the history of the site.

For children there is a large, multi-levelled playbarn/softplay centre with its own cafe, a small indoor bowling lane, a build-a-bear centre and paint-your-own pottery area. The playbarn is now also home to G-Joey. G-Joey was one of local airline Aurigny's trislander planes and was retired from active service in 2015. Outside there are trampolines and children's go-karts, plus an eighteen-hole mini golf course. There is also a restaurant on-site, providing meals and refreshments throughout the day and there is plenty of parking available as well as good bus links.

A visit to Oatlands Village could be combined with a visit to the Guernsey Freesia Centre/Fletcher's Freesias, which is just a short walk away. This delightful 3-acre nursery is a fascinating insight into Guernsey's horticultural industry, and visitors can see the freesias being grown, picked and packed.

www.oatlands.gg
http://freesiasbypost.com/our-centre

Oatlands Village. (Soo Wellfair)

Above and below: Oatlands Village. (Soo Wellfair)

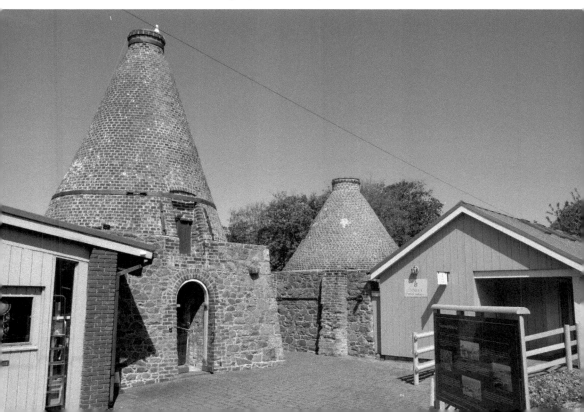

44. Les Vardes Quarry

Route du Port Grat, St Sampson, GY2 4TF

Back in the nineteenth century, quarrying was a massive part of Guernsey's industry, with over 250 working quarries during its heyday. Guernsey granite has always been much sought after, both for its strength and appearance, and granite from the Bailiwick was used to build the steps at St Paul's Cathedral in London. Les Vardes is now the only working quarry in Guernsey and is the location of a rather unusual nature trail.

Created in 2016, the Les Vardes nature trail takes you in a circular route around the quarry itself. Walkers are able to watch the daily operations of a working quarry in a safe and scenic way. The route is approximately 1 kilometre and offers some spectacular views across the west coast. The quarry offers much protection from the sea and land-based predators for wildlife, and has become a thriving habitat for a variety of species. It is definitely well worth taking a pair of binoculars with you on your walk. It is close to the west coast footpaths and within walking distance of Rousse Tower, so could be incorporated into a longer walk if desired.

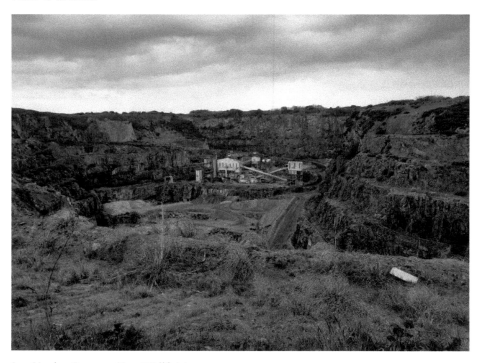

Les Vardes Quarry. (Soo Wellfair)

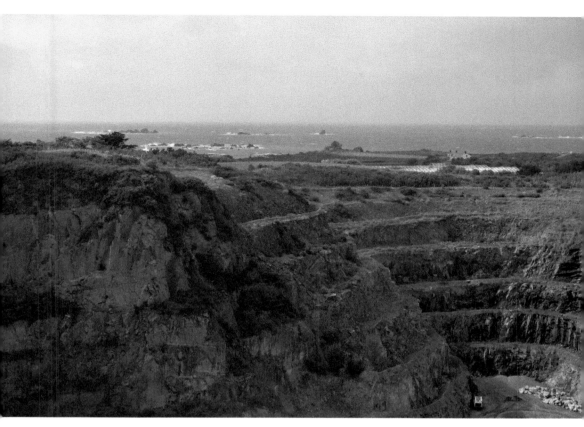

Les Vardes Quarry. (Soo Wellfair)

45. Island Hopping

Whilst in Guernsey, it's well worth taking the opportunity to visit some of the other islands in the Bailiwick. The closest is Herm, which is just a short twenty-minute ferry ride away. Herm is a walker's paradise with a stunning and varied terrain. One of Herm's most popular spots is Shell Beach, a stunning stretch of beautiful white sand and clear blue waters. Shell Beach is popular with families and swimmers. During the summer it is possible to hire kayaks and paddleboards and the kiosk at the top of the beach offers a wide range of refreshments.

For those wishing to stay in Herm, there is a lot to choose from in terms of accommodation. The White House Hotel offers a luxurious stay with excellent food and views across the sea. If you would like a cosier, more private experience, you can rent one of the island's cottages or cabins on a self-catering basis. And for the more adventurous or families, the camping facilities are excellent. Seagull Campsite offers a large number of self-equipped, pre-erected canvas tents. The Mermaid Tavern is one of the most popular places to eat and drink in Herm, and twice a year they hold their famous Cider and Ale Festival.

In just under an hour, you can visit the island of Sark. Sark is larger than Herm but still wonderfully quaint with no cars allowed on island. Most make their way around Sark by bicycle, hired from one of several outlets on the island. A horse and carriage ride is also a novel way to explore the island and can be booked in advance. The beautiful Seigneurie gardens are open to the public and guided tours can be booked in advance. One of the most spectacular sights in Sark is La Coupée, the crossing which takes you across from Sark to Little Sark. The annual sheep racing event attracts many visitors, as do the various music festivals which usually take place during the summer.

Alderney is the largest of the islands in the Bailiwick and can be reached by air or ferry. Alderney Week is a popular event which takes place every year and Alderney is also known for its beaches, historic fortifications and the famous blonde hedgehog. Alderney is the only island in the Bailiwick to have a railway. It was opened in 1847 by Queen Victoria and Prince Albert. It was originally a working railway, used for transporting building materials around the island, but now offers train rides to visitors. The diesel engine actually pulls two former London Underground carriages

and is quite a unique experience. There are other smaller islands in the Bailiwick of Guernsey, such as Jethou and Brecqhou, but these are unfortunately not open to visitors.

www.herm.com
www.sark.co.uk
www.visitalderney.com

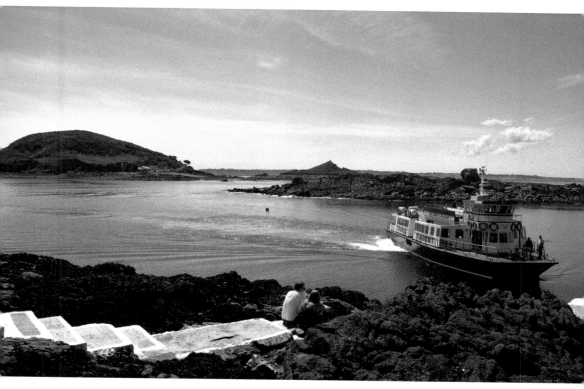

Above: The Rosaire steps, Herm. (Soo Wellfair)

Right: Shell Beach, Herm. (Soo Wellfair)

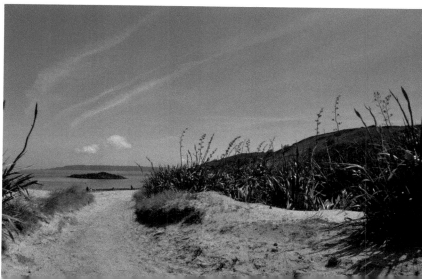

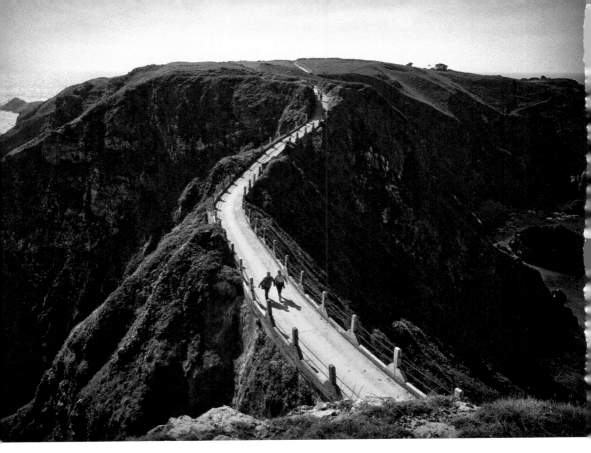

Above: La Coupée, Sark. (Kay Edwards)

Left: Alderney's blonde hedgehog. (Martin Batt)

46. Hedge Veg

Hedge veg stalls are a quintessential part of Guernsey life. More common in the island's rural parishes and down the quieter lanes, these delightful roadside stalls provide excellent local produce at a fraction of the cost in the shops. Traditionally, islanders started using hedge veg stalls to sell on any surplus produce from their own gardens and glasshouses, sometimes using a swap system within the local community. Although they may seem like something of a quirky novelty to visitors, the hedge veg stalls are actually an everyday part of how islanders buy their food. Many people will go out of their way to always purchase their potatoes, for example, from hedge veg rather than the supermarket. This is especially relevant in today's society, where food sustainability and shopping locally is more important than ever.

The modern-day hedge veg stall is a true testament to Guernsey's ability to adapt to the current needs of the community and to our visitors. Stall owners have come up with some clever and resourceful ideas over the years, and the items on offer now are varied and interesting. You will still find many stalls selling fruit, vegetables, free-range eggs, and flowers at fantastic prices, but you will also find so much more, including baked goods, confectionery, preserves, second-hand books and toys, kindling and logs, crafts, pottery, local coffee and freshly caught crab!

Hedge veg. (Soo Wellfair)

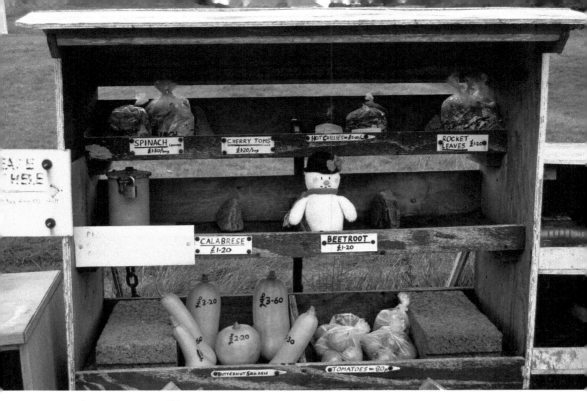

Hedge veg. (Soo Wellfair)

47. Cycling and Walking in Guernsey

Visitors to Guernsey are very much encouraged to explore the island by bicycle and on foot, as there are many parts of the island that can only be reached and appreciated this way. Cycling is popular on the island with the cycling infrastructure being continually improved. There are several sections of cycle lanes and shared paths with pedestrians. There is also a network of quiet lanes known as *Ruettes Tranquilles*, which are generally rural lanes with the right of way given to walkers, cyclists and horse riders with low speed limits. There are several bike shops on the island and companies which offer both short- and long-term cycle hire. Some hotels also have their own bikes for their guests to use, so it is worth checking in advance.

Every year Guernsey hosts a two popular walking festivals, one in spring and one in the autumn. Accredited tour guides from the Bailiwick of Guernsey Guild of Accredited Guides put together a schedule of interesting and varied walks around the Islands of Guernsey. The schedule is published well in advance with clear descriptions of what to expect. Walks are rated by the level of effort and type of terrain involved and an indication of the length and time is always provided, as well as guidance on bus routes to the starting points and pricing.

Above: Walking along Guernsey's coastal paths. (Soo Wellfair)

Right: Cycling is a great way to explore Guernsey's quiet lanes. (Soo Wellfair)

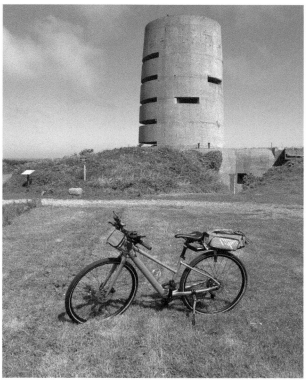

A *Ruette Tranquille* sign. (Soo Wellfair)

The walking festivals provide a fantastic opportunity to explore Guernsey and learn about the island's rich history. There really is something for everyone during these festivals. Typically you would find a mixture of town walks, coastal walks and rural walks around country lanes. Many walks are themed, and subject matters often include areas such as archaeology, architecture, flora and fauna, folklore, local history, geology, the Occupation and literature, to name but a few. It is also a good opportunity to visit some of the neighbouring islands as the festivals often include guided walks around Herm, Sark and Alderney.

In addition to the walking festivals, there are regular guided walks around St Peter Port and weekly coastal walks which start from a different point each week. These provide a safe, interesting way to explore the island as part of a group and you do not need to pre-book.

https://guernseyguidedtours.com/

48. Birdwatching and Nature Reserves

Birdwatching is extremely popular in Guernsey, with a number of bird hides located around the island. The Ornithology section of La Société Guernesiaise and the RSPB

Guernsey are both popular groups with an active membership and busy events are scheduled throughout the year for both members and the general public. Birdwatchers from around the world visit Guernsey to try to spot some of the rarer birds which can be found in the Bailiwick. Over 200 species are recorded here each year and it is thought that around eighty species choose Guernsey and the surrounding islands to breed. Important breeding areas are respected and access is strictly limited and at times prohibited to protect nesting birds. These areas are always well signposted. Many migrating birds use Guernsey as a place to stop and refuel en route to their destinations, and this is often when the rarer species can be spotted. Each season brings with it a different array of species, attracted to the wide variety of habitats that Guernsey offers. Some of the most eagerly photographed birds on Guernsey include woodpeckers, kingfishers, owls, peregrines and buzzards, to name but a few. It is even possible to spot puffins if you take a boat trip to one of the nearby islands such as Herm, Sark or Burhou (just off Alderney).

Visitors to Guernsey are welcome to visit any of the public bird hides located around the island, most of which have handy guides as to what you may expect to find in that area and a logbook to record what you have spotted. Many of these hides are within beautiful, quiet nature reserves and are a pleasure to visit, whether you are bird-spotting or not. The reserves, which are mostly owned and looked after by La Société Guernesiaise and the National Trust of Guernsey, truly are hidden gems. These are wonderful places to explore and relax whilst enjoying the peace and quiet as well as the local flora and fauna.

https://societe.org.gg/wp/nature-reserves/
https://nationaltrust.gg/walks

Bird hide at Le Grand Pré Nature Reserve. (Soo Wellfair)

St Germain Nature Reserve. (Soo Wellfair)

Le Grand Pré Nature Reserve. (Soo Wellfair)

49. Guernsey Kiosks

Nothing spells out the end of the Guernsey winter better than the opening of the beach kiosks. Although a small number remain open throughout the year, the majority close over the winter months, with their reopening greatly anticipated by islanders around the start of April each year.

A familiar site, dotted mostly around Guernsey's coastline, the kiosks provide much welcome refreshments to beach users and walkers alike, and no two kiosks are the same. There are larger kiosks made of Guernsey granite, smaller hut-like structures, some with tea gardens and some on wheels! They are all a little bit different and have their own quirks and attractions. Most locals will have their favourite kiosk, although most will make the effort to visit as many as possible across the warmer months as they all have something different to offer, whether it be the location or the food on offer. Some kiosks are famous for their home-made cakes or local ice cream. Others are better for hot food, and others are popular because they offer good beach access, spectacular views or have great parking.

The kiosks are such an integral part of Guernsey's personality and are an absolute must when exploring the island, either by foot, bike, bus or car.

A Guernsey kiosk. (Soo Wellfair)

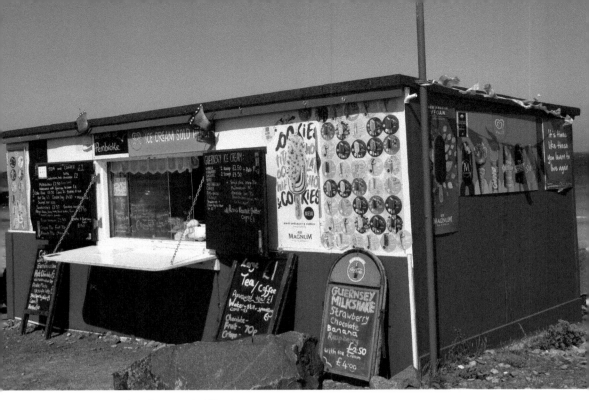

A Guernsey kiosk. (Soo Wellfair)

50. Tennerfest

The Tennerfest is another of Guernsey's most eagerly anticipated annual events. Islanders and visitors have been enjoying this delectable food festival since the 1990s and it continues to be a great success year after year. Tennerfest begins on 1 October each year and usually lasts into mid-November. During this time, participating restaurants offer a set menu, at a reduced rate, some as low as £10. Originally seen as an end-of-season treat for islanders who may have worked a very busy summer, Tennerfest is now becoming well known off island, and many visitors now come specifically for the Tennerfest experience. The various menus are compiled into both a printed and online guide and with the online version, results can be filtered by location, pricing and dietary requirements.

It is a wonderful way to experience some of Guernsey's famous delicacies, such as our local seafood. Spider and chancre crabs, scallops, oysters, mackerel, skate, brill and turbot are just an example of what is available in local waters. You may also find locally reared pork, lamb and beef or the famous Guernsey bean jar, which has been a staple part of the Guernsey diet for centuries. Traditionally made with haricot and butter beans and either beef shin or ham hock, it is a simple but delicious dish that never disappoints. If you have a sweeter tooth you may like to try Guernsey Gâche,

a type of enriched fruit bread which is delicious toasted and slathered with Guernsey butter. Or perhaps a serving of Gâche Mélée, an indulgent apple suet pudding best served hot with a scoop of Guernsey ice cream.

The variety of what's on offer at the Tennerfest changes year by year, with more establishments getting on board and offering something a little different. For example there are now some bars involved offering a more liquid-based menu and some hotels combine their Tennerfest menus with reduced rates on their rooms. Most establishments get very busy during the Tennerfest period so booking in advance is very much recommended.

www.tennerfest.com

A Tennerfest meal. (The Rockmount)

A Tennerfest meal. (The Rockmount)

Bibliography

Printed Resources

Chauvel, A. D and Forestier, M., *The Extraordinary House of Victor Hugo in Guernsey* (Channel Islands: Toucan Press, 1975)

De Garis, M., *Dictiounnaire Anglais-Guernesiais* (Andover: Phillimore, 1967)

De Garis, M., *Folklore of Guernsey* (Channel Islands : ©La Société Guernesiase, 1975)

Festung Guernsey, *German Tunnels in Guernsey, Alderney and Sark* (Guernsey: Channel Island Art & Books)

Fothergill, A., *Megalithic Guernsey* (Guernsey: Digital Press Pictures Ltd, 2006)

Gavey, E., *A Guide to German Fortifications on Guernsey* (Guernsey: Guernsey Armories, 1967)

Historic Houses Association, *Stately Ghosts: Haunting Tales From Britain's Historic Houses* (London: VisitBritain Publishing, 2007)

Monaghan, J., *The Story of Guernsey: The Island and Its People* (Guernsey: Guernsey Museums & Galleries, 2010)

O'Neil, M. A., *The History of Castle Cornet* (Guernsey : GP Printers, 1952)

Stephens Cox, G., *Guernsey's Medieval Castles* (Channel Islands: Toucan Press, 2012)

Stephens Cox, G., *St Peter Port – A Short History* (Bridport: Creeds UK, 2007)

Online Resources

www.bbc.co.uk
www.festungguernsey.org.gg
www.gov.gg
www.maisonsvictorhugo.paris.fr
www.museums.gov.gg
www.nationaltrust.gg
www.visitguernsey.com

About the Author

Soo Wellfair was born in Berkshire, England. She first visited and fell in love with Guernsey in 2000. She quickly adopted the island as her second home and now lives in Guernsey with her husband and children, where she works as a silver accredited tour guide and freelance writer. As a tour guide, Soo specialises in tours for families and has a special interest in the folklore of Guernsey and the social history of the island.